JEWISH ART
MASTERPIECES
FROM THE ISRAEL MUSEUM, JERUSALEM

JEWISH ART
MASTERPIECES

FROM THE ISRAEL MUSEUM, JERUSALEM

Iris Fishof

HUGH LAUTER LEVIN ASSOCIATES, INC.

מוזיאון ישראל, ירושלים
the israel museum, jerusalem
متحف اسرائيل، اورشليم القدس

© 1994 Hugh Lauter Levin Associates, Inc.
Design by Ken Scaglia
Editorial production by Diane Lawrence
Production coordination in Israel by Rebecca Haviv
Photographs and text copyright © 1994 The Israel Museum, Jerusalem
I S B N 0-88363-195-4
Printed in China

We are indebted to those who provided the cultural and historical perspectives for the works in this volume. Contributors' initials follow their respective essays.

Ruth Apter-Gabriel

Alia Ben-Ami

Chaya Benjamin

Michal Dayagi-Mendels

Naomi Feuchtwanger-Sarig

Iris Fishof

Hayim Gitler

Yael Israeli

Esther Juhasz

Ester Muchawsky-Schnapper

Daisy Raccah-Djivre

Ora Schwartz-Be'eri

Elana Shapira

Shlomit Steinberg

Rivka Weiss-Blok

Martin Weyl

CONTENTS

PREFACE
7 Dr. Martin Weyl

9 INTRODUCTION
Dr. Iris Fishof

Ancient Art
JERUSALEM
18 Ivory Pomegranate

JERUSALEM
20 Coin of Judah

JERUSALEM
22 Sarcophagus from a Nazarite Family Tomb

ROME
24 Gold-Glass Base

BETH SHEAN
26 Mosaic Pavement

PROVENANCE UNKNOWN
28 Multiple-Nozzle Lamp

PROVENANCE UNKNOWN
30 Oil Lamp with Menorah

Synagogues and Torah Decorations
ITALY
32 The Vittorio Veneto Synagogue

GERMANY
ELIEZER SUSSMANN
34 The Horb Synagogue Ceiling

POLAND
36 Torah Ark Doors

YEMEN
38 Torah Finials

GERMANY
40 Torah Ark Curtain

ITALY
42 Torah Ornaments

ROME
44 Torah Wrapper

AFGHANISTAN
46 Torah Decorations

TURKEY
48 Torah Shields

GERMANY
JOHANN CHRISTOPH DRENTWETT
50 Torah Shield

GERMANY
JACOB POSEN
52 Torah Ornaments

YEMEN
54 Prayer Stand

SOUTHERN YEMEN
56 Torah Crown with Finials

Illuminated Hebrew Manuscripts
GERMANY
58 Birds' Head Haggadah

SPAIN
60 Sassoon Spanish Haggadah

NORTHERN ITALY
62 The Rothschild Miscellany

EASTERN EUROPE
64 Prayer Book of the Rabbi of Ruzhin

MORAVIA
NATHAN OF MEZERITZ
66 Grace after Meals Manuscript

AUSTRIA
AARON WOLF HERLINGEN
68 The Five Scrolls in Micrography

The Sabbath and Festivals
WESTERN EUROPE
70 Hanging Sabbath Lamps

ISRAEL
ZELIG SEGAL
72 Sabbath Candlesticks

EUROPE
74 Spice Boxes

SOUTHERN GERMANY
76 Sukkah

GERMANY
78 Hanukkah Lamp

GERMANY (?)
80 Esther Scroll

SPAIN
82 Lusterware Passover Plate

Jewish Home and Jewish Life
SOUTHERN GERMANY
84 Mizrach

ERETZ ISRAEL
MOSES SHAH (?)
86 The Fall of Goliath

TURKEY
DAVID ALGRANATI
88 Amuletic Paper-Cut

YEMEN
90 Amulet Necklace

HOLLAND
SHALOM ITALIA
92 Marriage Contract

NORTHERN ITALY
94 Bridal Casket

BOHEMIA
96 Burial Society Glass

MOROCCO
98 Breastpieces

KURDISTAN
100 Woven Wool Carpet

BOHEMIA
102 Circumcision Set

Modern Jewish Art
GERMANY
MORITZ OPPENHEIM
104 The Wedding

BERLIN
EL LISSITZKY
106 Illustration for "Boat Ticket"

ERETZ ISRAEL
MARC CHAGALL
108 Interior of a Synagogue in Safed

ISRAEL
MENASHE KADISHMAN
110 The Sacrifice of Isaac

RUSSIA
ISSACHAR RYBACK
112 Still Life with Jewish Objects

114 REFERENCES

117 INDEX

PREFACE

The Israel Museum is located in Jerusalem, the spiritual core of the Jewish people. Set on a hill in the geographical center of the city, it is ringed by the Knesset (Parliament) Building, the government ministries, the campus of the Hebrew University, the Monastery of the Cross, and the panorama of the city itself.

The museum attracts some 800,000 visitors a year: the local population as well as tourists from all over the world, Jews and non-Jews alike. For the vast majority, both young and old, the museum plays an important educational role. In addition to the vast archaeological and art treasures which are on display, a visit to The Israel Museum is for many of the non-Jewish visitors their first encounter with Jewish culture.

The Israel Museum encompasses a wide range of artistic and cultural treasures, placing special emphasis on its archaeological, Judaica, and Jewish ethnography collections. It houses the most comprehensive collection of Jewish art in the world, and is the only museum where the visitor can get a complete and consistent survey of the archaeology of the land of Israel. A visitor may begin his tour in the archaeology wing, work his way through the Judaica department, experience the ethnography exhibits of local cultures and of the Jewish diaspora, and continue on through the contemporary Israeli art exhibitions where the rich collections of Jewish paintings and sculptures complete this survey, adding another dimension to the visitor's "Jewish experience." Throughout the museum tour the visitor is able to trace common Jewish symbols and motifs that have prevailed throughout the ages.

Since its inception The Israel Museum has continually enlarged and enriched its Judaica and ethnographic collections. This has been accomplished by conducting field surveys among immigrants to Israel, as well as through the acquisition of entire collections of Jewish treasures both in Israel and abroad. We are greatly indebted to our donors, whose concern and interest in our institution have helped these important elements of the Jewish legacy reach our museum.

In this volume we have tried to present the reader with an overall picture of our Jewish art collections, with special emphasis on traditional Judaica.

DR. MARTIN WEYL
Director, The Israel Museum

INTRODUCTION

In this volume, a selection of highlights of Jewish art from The Israel Museum collection has been specially compiled. Selecting the representative items from the world's most comprehensive collection of Jewish art was an enjoyable but difficult task. We have tried to include a variety of archaeological artifacts, Jewish ritual and ethnographical objects, as well as several modern works of art. Special emphasis has been placed upon ceremonial objects from the Judaica Department.

The items presented here were not chosen solely for their aesthetic appeal, rarity, or quality of workmanship: alongside choice objects of high artistic caliber are examples of more common folk art. In addition to a number of renowned masterpieces, several less-known works have been incorporated, including the recently acquired *Interior of a Synagogue in Safed* by Marc Chagall, *Still Life with Jewish Objects* by Issachar Ryback, and a Torah crown from the remote community of Aden in southern Yemen.

History of the Collections

The Jewish cultural treasures of The Israel Museum have been progressively gathered over the last nine decades. The origins of the collections can be traced back to 1906 when Boris Schatz founded the Bezalel School of Arts and Crafts. Schatz set up a collection of archaeological and traditional Jewish folk objects to inspire his young students in their quest to create a new national style. At first, the collection could be viewed only at the annual Bezalel students' exhibitions, but in 1912 the Bezalel Museum opened its doors to the public of Jerusalem. During the First World War the collection was hidden in a large cistern in the courtyard of the school. In 1925, under the directorship of Mordechai Narkiss, the museum was expanded and renamed the Bezalel National Museum. In 1965 the collections of the Bezalel National Museum were integrated into the newly established Israel Museum.

Over the years donations of individual objects, and even entire collections, have enriched the displays of what has become the repository of the Jewish people. Among the people who assembled such collections, and who were instrumental in having them brought together at The Israel Museum, were several prominent figures.

Dr. Abraham Ticho, the famous Moravian-born ophthalmologist, immigrated to Jerusalem in 1912. He collected various objects from all over the world, but was primarily interested in Hanukkah lamps. His extensive and impressive collection was bequeathed to the museum in 1980 by his widow, the artist Anna Ticho, upon her death.

Dr. Heinrich Feuchtwanger, a dentist, arrived in Jerusalem in 1936, having begun to collect Judaica objects a decade earlier in his native Munich. He continued collecting Judaica in Jerusalem, often coming across rare objects in the shops and markets of the Old City. The Feuchtwanger collection was donated to The Israel Museum in 1969.

One of the few private collections to arrive in Israel after the Second World War was the Stieglitz collection. Abraham Stieglitz was an antique dealer and purveyor to the royal palace in Cracow, Poland, at the beginning of this century. During the war, part of his collection was hidden away and eventually returned to his son Joseph. After the

war the Stieglitz family immigrated to Palestine where Joseph opened a shop in Tel Aviv and continued to augment his already impressive array of Jewish art. This important collection, containing many exceptional objects of a very high standard created by professional craftsmen, is very different from the Feuchtwanger collection, which focuses more on objects of folk art and tradition originating from rural communities. The Stieglitz Collection was donated to the museum in 1987.

During the Holocaust, thousands of Jewish ceremonial art objects were lost by individuals and communities. Many of them eventually found their way to the Bezalel National Museum after the war through the Jewish Cultural Reconstruction organization, which distributed recovered Jewish property among Jewish cultural institutions in America and Israel.

The Scope of the Collections

The treasures of Jewish art and culture at The Israel Museum include objects brought to Israel from virtually all Jewish communities throughout the world, both oriental and occidental. This gives the museum's Judaica collection a certain versatility and all-encompassing nature and makes this selection one of the most comprehensive of its kind. This unique aspect of the collection is due in part to the fact that cultural remnants of vanishing Jewish communities arrived in Israel, accompanying the waves of immigrants which flowed into the country following the establishment of the Jewish state. In addition to the wealth of Judaica collected, invaluable ethnographical material was rescued during the course of field surveys conducted by the Julia and Leo Forchheimer Department of Jewish Ethnography at The Israel Museum.

Accordingly, The Israel Museum's collection of Jewish artifacts at the Skirball Department of Judaica originates from many different communities: Ashkenazi, Sephardi, and Oriental. The Ashkenazi strain of Judaism originated in Germany, eventually spreading throughout the continent, and taking hold particularly in Eastern Europe. Among the most cherished treasures of the museum are medieval Hebrew illuminated manuscripts from Europe which are of special interest. The *Birds' Head Haggadah,* the earliest known illustrated Passover haggadah, is one such treasure of unique importance. The Horb synagogue, painted by Eliezer Sussmann, is another precious remnant of Ashkenazi culture and its traditional art.

The Sephardi Jews, descendants of the Jews expelled from Spain and Portugal some five hundred years ago, settled in Italy, Holland, Turkey, the Balkans, and North Africa. A few rare Jewish ceremonial objects which come from preexpulsion Spain are preserved at The Israel Museum. They include the fourteenth-century *Sassoon Haggadah* and the lusterware seder plate, both objects rare and unique examples of their kind. Moreover, thousands of artifacts from the Sephardi diaspora have made their way to The Israel Museum and form large collections from some vanishing cultures. A few examples of the museum's considerable holdings of ethnographical and Judaic objects from Morocco and the Ottoman Empire are contained in this volume; they include unusual Torah shields and a papercut from Turkey, as well as embroidered breastpieces from the traditional dress of Jewish women in Morocco.

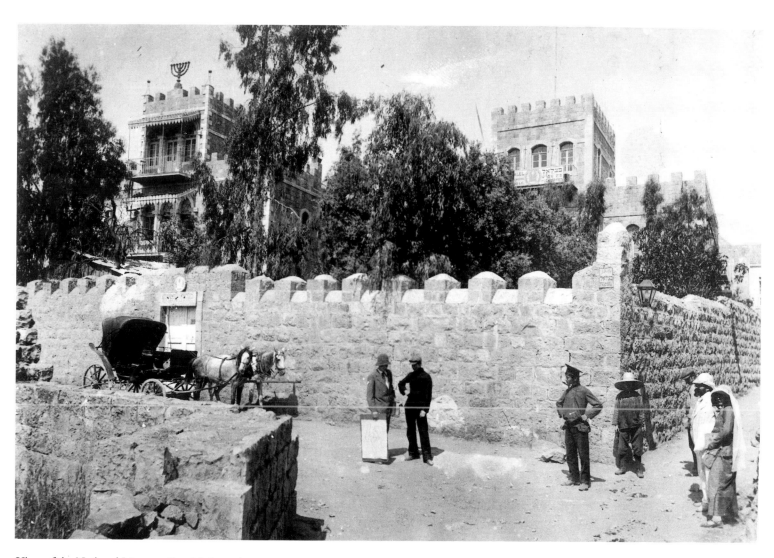

View of the National Museum Bezalel, Jerusalem,
photographed during the 1920s.

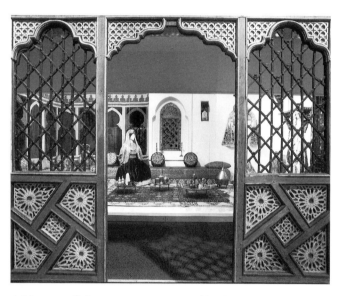

A Moroccan living room, reconstructed in the Sala Wing for Israel Communities at The Israel Museum.

From Renaissance Italy some outstanding Jewish treasures have survived. One well-known example is the magnificent *Rothschild Miscellany* of the fifteenth century, with its beautiful illuminations. Another unique work of art is the bridal casket (*cofanetto*), presented to a Jewish woman in northern Italy in the fifteenth century. From the same region, but of a somewhat later period, is the splendid baroque synagogue from Vittorio Veneto.

The roots of oriental Jews can be traced back to Yemen, Kurdistan, Afghanistan, Iran, and Iraq. In oriental communities the Torah scroll is generally kept in a wooden or metal case. The museum houses a wide variety of such Torah cases, some of them with particularly unique forms and decorations, such as the unusual Torah set from Afghanistan featured in this book. A striking eighteenth-century synagogue prayer stand (*tevah*) from Yemen, skillfully carved in wood, is also included.

The Artists

Many of the craftsmen who created early works of Judaica remain unidentified, and only a few of the early Jewish artists are known by name.

Shalom Italia was a seventeenth-century Italian copper engraver. He settled in Holland and there produced some magnificent illustrated Esther scrolls and apparently several rare marriage contract forms (*ketubbot*) as well, including one particularly impressive example from Rotterdam dated 1648, now part of The Israel Museum collection.

The revival of the art of Hebrew manuscript illumination in the eighteenth century brought to light a number of skilled scribe-artists. Aaron Wolf Herlingen was a professional scribe at the Royal and Imperial library in Vienna. He is represented in this book by his *Five Scrolls,* written in minute script in several languages and illustrated with delicate drawings. The work of his contemporary, Nathan, son of Shimshon of Mezeritz, is exemplified by the profusely illustrated Grace after Meals manuscript.

Several craftsmen expressed themselves artistically by decorating the interiors of synagogues. Eliezer, son of Shlomo Katz Sussmann, of Brody, Ukraine, was an itinerant eighteenth-century artist who painted murals in synagogues in Germany. His works include the synagogue interior from Horb, Bavaria, presently on display at The Israel Museum and featured herein. The Jewish artisans who created the heavy tin doors for the Torah ark of the Rema synagogue in Cracow proudly signed their names to their work, as well as on another pair of seventeenth-century Torah ark doors from Cracow.

The exclusion of Jews from goldsmiths' guilds in great parts of Western Europe until the eighteenth century, particularly in Germany, forced them to commission ritual objects from Christian artisans. The Torah shield from Augsburg, for example, was made by the Christian goldsmith Johann Christoph Drentwett. The spice box from Nuremberg, pictured with a group of spice boxes of different shapes, was created by the renowned Christian artisan Johann Conrad Weiss. Later, however, the situation changed, and Jewish artisans and firms specialized in the creation of Jewish ceremonial art crafted in gold and silver. One of the most notable manufacturers of this sort was the firm of Posen, whose elegant set of Torah ornaments is presented in this volume.

In Islamic countries a different situation prevailed, and most of the artists and silversmiths were Jews. Some of them achieved a very high level of craftsmanship, as can be attested to by the jewelry and Torah ornaments which have been selected from the museum's collections.

Embroidery and weaving were in most cases performed by Jewish artisans, both in the East and in the West. In many countries, particularly in the East, it was thought that Jews possessed "professional secrets" with regard to this type of work. Professional embroiderers made Torah ark curtains (*parochot*) for the synagogues in Bavaria, for example. One such richly embroidered curtain for the Torah ark from southern Germany, evidently embroidered by a professional Jewish artisan although unsigned, is housed at The Israel Museum. Some of the artists who created the curtains and were active in the eighteenth century are known by name, such as Elkone of Naumburg and Kopel Gans. In Italy, Torah mantles and wrappers (*mappot*) were embroidered by Jewish women and often bear their names. On the round cloth (*malbush*) placed between the finials of the Afghanistan Torah scroll, the embroidered inscription bears the name of a woman, although it is unclear as to whether she made the piece or simply donated it to the synagogue.

All of these early artists, Christian and Jewish alike, produced functional art that was decorative in nature. The objects were designed for use by Jews in performing their religious duties in the synagogue and in the home. Only from the nineteenth century onward do we come across Jewish artists in the modern sense of the word, creating art for art's sake. Moritz Oppenheim is traditionally considered to be the first Jewish painter. His well-known series of "Pictures of Traditional Jewish Family Life" is represented here by an oil painting depicting a Jewish wedding. Other examples of works from the modern era include, among others, one from El Lissitzky, a collage for an illustration; and another from Marc Chagall, perhaps the most important Jewish painter of our time, a synagogue painting made on his trip to Eretz Israel in 1931.

Contemporary Judaica

The tradition of ordering ritual art from artists continues today. In recent years we have witnessed an increased interest and activity among designers in Israel and abroad who seek to find new ways of creating contemporary Judaica. They attempt to design ritual objects that reflect contemporary art, using innovative forms, materials, and techniques. Judaica designed by artists such as David Gumbel, Menahem Berman, Arieh Ofir, Zelig Segal, and the younger Amit Shor are exhibited at the museum, linking the present with the past. Zelig Segal's candlesticks "In Memory of the Destruction of the Temple," are an example of this prevailing movement in contemporary Judaica design.

Jewish Art—Attitude, State of Research, Iconography, and Style

The existence of visual Jewish art raises the issue of the attitude towards art in Jewish thought. It is commonly believed that the Jewish religion prohibits any visual artistic expression. But the biblical prohibition against creating any graven image, stated in the Second Commandment, "Thou shalt not make unto thee any graven image . . ." (Exodus 20:4), appears to have been interpreted as a prohibition against idol worship in the following verse, "You shall not bow down to them nor serve them" (Exodus 20:5).

From rabbinical literature dealing with the issue, it appears that the main aversion has always been against three-dimensional art, which might simulate the implements of the Temple. Indeed, there has been hardly any Jewish sculpture prior to the modern era. Two-dimensional painting has been accepted in Hebrew illuminated manuscripts since the thirteenth century. The phenomenon of distorting the human figures in certain European Hebrew manuscripts, however, as in the *Birds' Head Haggadah,* may indicate an attempt to avoid drawing complete human figures. In Islamic countries, on the other hand, Jews were often influenced by local trends; because the Islamic culture prohibits the making of statues or any image, they refrained from depicting human figures.

This tendency to adopt local styles and traditions is characteristic of Jewish art. It can be inferred from the selection

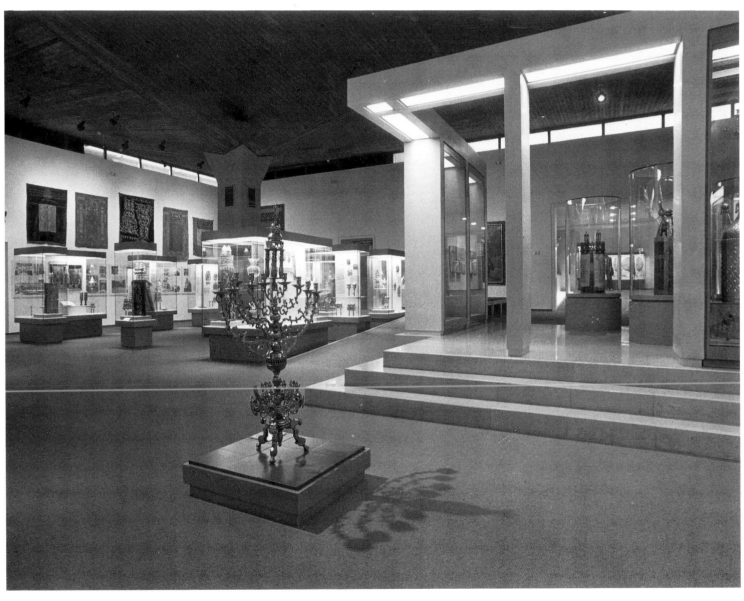

View of the Max Mazin Wing for Jewish ceremonial art
at The Israel Museum.

of artistic works portrayed in this book that there is no typical Jewish style. Wherever Jews lived they adopted the style of their host culture. Among other items which exemplify this trend, we have presented an Italian baroque synagogue, a set of Torah ornaments created in a Neo-Gothic style, and the *Rothschild Miscellany* created in an Italian Renaissance fashion.

On the other hand, recurrent symbolic and narrative motifs attest to the existence of a rich Jewish iconography. Various themes prevail throughout the ages and can be traced in numerous cultures, sometimes revealing complex interrelations with similar non-Jewish themes.

The iconography of many biblical scenes is not specifically Jewish, as is the case with the narrative scenes depicting David and Goliath, here represented on a glass painting, or the story of Judith and Holofernes shown on a Hanukkah lamp. Some of the ritual scenes, however, such as the baking of the matzot in the *Birds' Head Haggadah,* do have a specifically Jewish iconography, which continued to influence later manuscripts and printed editions.

The inclusion of examples of ancient Jewish art in this volume demonstrates how certain Jewish symbols, such as the candelabrum (menorah) and the ram's horn (shofar) have prevailed from antiquity. In our selection of archaeological pieces for example, the menorah is found on the oil lamp, the synagogue mosaic, and the Roman gold glass. This motif continues to appear in more "modern" objects, such as the Cracow Torah ark doors and the Torah ornaments from Italy.

Jewish art is a relatively young discipline. While ancient Jewish art as well as modern Jewish art have been studied within the framework of archaeology and art history, the field of Jewish ceremonial art has been systematically studied only within the last two or three decades. While some aspects of Jewish art, such as illuminated manuscripts of the Middle Ages, have been studied in depth, others are still waiting for the opportunity to be investigated in detail. For years the study of Jewish art was adrift among different disciplines—folklore, religious science, history, social history, and art history. It seems obvious that in order to deal with some of the major questions and problems which abound in the realm of Jewish art, there is a need for interdisciplinary studies to be carried out by experts from a number of fields.

The aim of this volume is to give the reader a glimpse of some of the magnificent collections of The Israel Museum. Due to the vast nature of the collections, we have presented only a small fraction of the museum's wonders of Judaica and Jewish art. In our selection we have attempted to give the reader a taste of Jewish art in all its shapes and forms: as ancient artifacts, Jewish ceremonial pieces, items made specifically by and for Jews of an ethnographic nature, as well as modern and contemporary art. We have also tried to show the continuing link between the past and the present in Jewish culture and art.

DR. IRIS FISHOF
Chief Curator of Judaica and Jewish Ethnography

JEWISH ART
MASTERPIECES
FROM THE ISRAEL MUSEUM, JERUSALEM

IVORY POMEGRANATE

Jerusalem, Mid 8th century B.C.E.

The gracefully carved ivory pomegranate has a rounded body, tapering toward its flat bottom and tall, narrow neck. The neck terminates in six lengthy petals, two of which are broken. The body is solid with a small rounded hole in the base, indicating that it was probably mounted on a rod. Unlike the globular ripe pomegranate which is frequently depicted in ancient art, our pomegranate represents the fruit in its blossom stage.

Around the shoulder of the pomegranate is a carefully incised inscription in ancient Hebrew script, part of which is broken off. The inscription is arranged in a circular line with irregular intervals between the letters and reads: *Qodeš Kohanim l-beyt [Yahwe]h*—"Sacred donation for the priests of (in) the House of Yahweh."

The term "*qodeš*" designates a thing set apart for a sacred purpose. "House of Yahweh" (or House of the Lord) most probably refers to the Temple in Jerusalem.

Although a number of pomegranates were discovered in excavations in Israel and neighboring lands, none of them were inscribed.

The juicy pomegranate fruit with its multitudinous seeds was a popular symbol of fertility and fecundity in ancient times and was widely used in the sacred and secular art of various cultures throughout the ancient Near East. The pomegranate is frequently mentioned in the Bible and is counted among the seven kinds of fruit with which the land of Israel is blessed: "A land of wheat, and barley, and vines, and fig trees, and pomegranates; a land of olive oil and honey . . ." (Deuteronomy 8:8).

The pomegranate was a favorite motif in the Temple of Solomon, and decorated the capitals of two freestanding columns named Jachin and Boaz at the entrance to the Temple (I Kings 7:42). The Bible describes in great detail the robe of the High Priest, which was embellished all along its hem with pomegranates of blue, purple, and scarlet, and golden bells (Exodus 28:33–34).

This thumb-sized pomegranate is believed to be the only known relic from Solomon's Temple in Jerusalem. It probably served as a decorative head of a ceremonial scepter, used by the Temple priests during some kind of ceremony.

M D M

Ivory.
H: 1 ¹¹/₁₆ in. (4.3 cm); Diam: ¹³/₁₆ in. (2.1 cm).
The Israel Museum Collection 88.80.129.
Donation of a friend from Basel, Switzerland.
Photograph: Nahum Slapak.

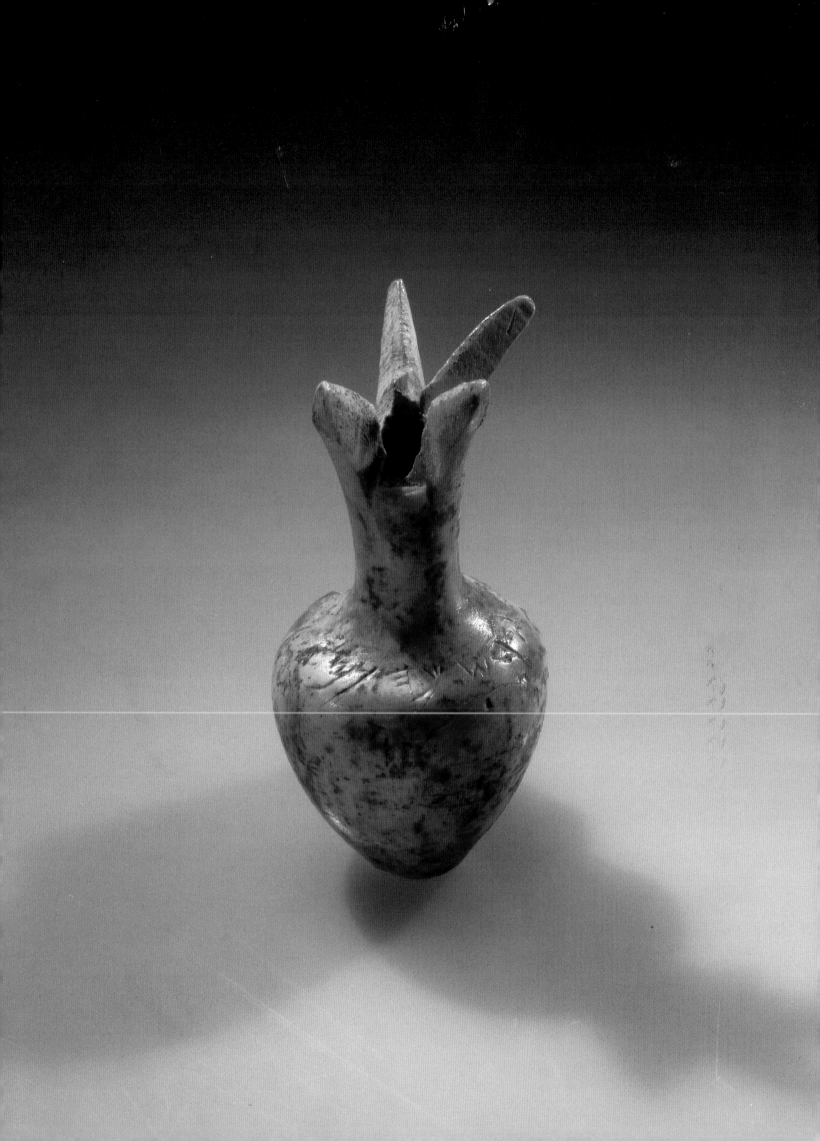

COIN OF JUDAH

Jerusalem, c. 350 B.C.E.

This minute silver coin called an obol was minted in Jerusalem. One of the earliest Jewish coins and an outstanding example of Jewish numismatics, it was apparently found some 9 miles (15 kilometers) north of Jericho.

On its obverse, the coin bears a depiction of a lily (fleur-de-lys). This white flower, the *lilium candidum,* was a symbol of purity and was regarded as the choicest of flowers. In the words of the prophet Hosea, the lily became a symbol of the people of Israel: "I will be like the dew for Israel; he shall blossom like the lily . . ." (Hosea 14:6). The lily is also allegorically referred to in the Song of Songs (Canticles 2:1), and appears as a popular simile in Hebrew poetry. This flower, which was an important source of perfume, was certainly used for sacred purposes and constituted one of the major spices of ancient times. Though not found in profusion in Israel today, we may assume that the lily was once common in all parts of the country.

The lily motif is apparently derived from the design that graced the capitals of the two main pillars of the Temple in Jerusalem, Jachin and Boaz (I Kings 7:19). The symbol became popular in Jewish art of the Second Temple period and appears on other coins struck in Jerusalem during the second and first centuries B.C.E. under Antiochus VII, John Hyrcanus I, and Alexander Jannaeus.

On the reverse, an image of a bird is portrayed. Though the exact species cannot be determined with certainty, from the depiction it may represent either a falcon or a hawk. The heraldic form of the bird is copied from contemporary coins of Asia Minor which depict other birds, such as eagles, in a similar fashion.

Near the bird's head the inscription YHD appears in ancient Hebrew script. Apparently, this expression has a twofold meaning, indicating both the province of Judah and its capital, Jerusalem. This assumption is based on the fact that at the time of the minting of this coin, as well as in previous centuries, YHD was the designation for Jerusalem. In II Chronicles 25:28, it is mentioned that Amaziah, King of Judah, was buried with his fathers in the city of Judah (769 B.C.E.). There is no doubt that the "city of Judah" is Jerusalem, the burial place of Judean kings. On the other hand, Yehud (YHD) was also the name of the province of Judah during the fifth and fourth centuries B.C.E.

This specimen, as well as other small coins bearing the YHD inscription, was probably minted under the autonomous authority of the province. If the Persian authorities had commissioned the coinage, they could have afforded to produce larger denominations.

H G

Silver.
Wt: 0.01 oz. (0.35 g); Diam: ⅓ in. (0.85 cm).
The Israel Museum Collection 14587.
Gift of the Bessin Family, Canada.
Photograph: Yoram Lehmann.

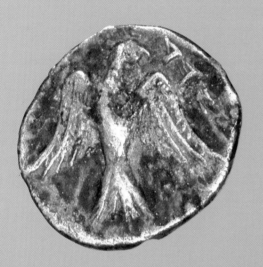 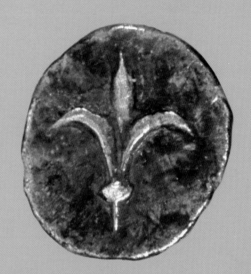

SARCOPHAGUS
FROM A NAZARITE FAMILY TOMB

Jerusalem, First half of 1st century C.E.

From the time of Herod and his dynasty until the destruction of the Temple, Jerusalem was renowned for the magnificence of its buildings—from the king's palace in the west to the temple built by Herod in the east. But not only the living were housed in splendor. Some distance from the city walls, richly decorated funerary monuments were erected near the burial caves. These splendid monuments and the elaborate tomb facades of wealthy Jerusalem families were built in a mixture of styles, characteristic of the late Hellenistic and early Roman periods. The decorations were carved by Jerusalem craftsmen, who incorporated motifs from the Jewish art of the time.

This sarcophagus from a tomb on Mount Scopus is the most elaborate of the small group of Jewish sarcophagi found in Jerusalem. The ornamentation, consisting of various floral motifs, is skillfully carved and conveys a feeling of movement and naturalism, even though it is composed of highly stylized elements. The front of the sarcophagus is decorated with a symmetrical floral motif in shallow relief enclosed in a molded frame. In the center is a stylized lily, from which spring meandering stems with leaves and two large, pendent bunches of grapes. Six rosettes, each different, fill the empty spaces.

The tomb in which the sarcophagus was discovered is one of the finest sepulchers of the wealthy families of Jerusalem. Two sarcophagi and fourteen ossuaries were discovered in the tomb, but otherwise it was almost completely empty. Inscriptions on the ossuaries mention the names of Hananiah, son of Yehonatan the Nazarite, and Shalom (Salome), wife of Hananiah. It may be significant that Hananiah's bones were placed in a plain ossuary, while the bones of his wife were laid in a decorated one.

The Nazarite custom was well-known among the Jews. Nazarite men took a vow to abstain from drinking wine and from cutting their hair for a certain period of time. Nazarites came from all levels of society, and Yehonatan the Nazarite, whose family was buried in this tomb, must have been a member of a prominent family and a man of means.

Y I

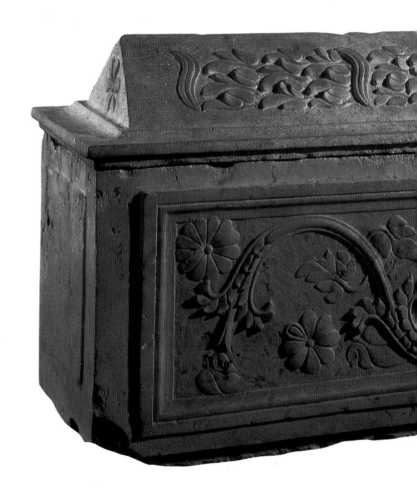

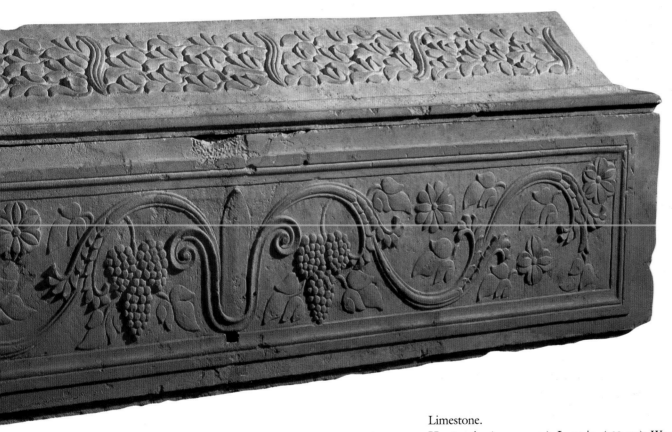

Limestone.
H: 16–17 in. (41–42.5 cm); L: 74 in. (188 cm); W: 18 in. (45.5 cm).
Excavations of the Hebrew University, Jerusalem.
Israel Antiquities Authority 74-1552.
Photograph: Nahum Slapak.

GOLD-GLASS BASE

Rome, 4th century C.E.

Bowls embellished with incised gold leaf pressed between two layers of glass were among the various luxury items produced in the Hellenistic world. In the late Roman period, plaques quite similar to these vessels were embedded in the plastered walls of the catacombs in Rome, next to the burial niches, perhaps as a means of identifying the interred. These small disks appear to have been the bases of bowls or cups, the sides of which were broken so that the bases could be inserted into the catacomb walls. Some of the disks still retain part of their original sloping sides.

This fascinating custom seems to be unique to ancient Rome. The gold-glass bases became known with the discovery of the Roman catacombs in the seventeenth century. Hundreds of these bases have reached us, though hardly any were recovered from controlled excavations. Most bear Christian motifs, while some are decorated with biblical scenes, animals, or "portraits" of the deceased. Only a dozen or so contain Jewish motifs. The locality of the phenomenon points to a production center in Rome itself. Similarities between the Christian and Jewish plaques suggest that the same workshops were patronized by Jews and Christians alike.

This gold-glass base is an outstanding example of the Jewish bases that have been discovered. The design is divided into two registers. The upper register contains a gabled Ark of the Law, its open doors revealing three shelves of scrolls shown in profile. It is flanked by birds standing on roundels. In the lower register, a palm branch (*lulav*), citron (*etrog*), shofar, amphora, and two lions flanking a menorah are depicted. The whole scene is set within a circle.

This small glass piece contains most of the characteristic motifs of Jewish art of the late Roman and early Byzantine periods. This kind of design commemorates the Temple, its ritual appurtenances, and its ceremonies. Surprisingly, there is greater detail here, despite the complicated gold-glass technique, than in many larger representations of a similar nature.

Y I

Glass and gold leaf.
H: ⅓ in. (0.9 cm); Diam: 5 in. (12.7 cm).
Previously in the collection of Castle Goluchow, Poland.
The Israel Museum Collection 66.36.15.
Gift of Jakob Michael, New York, in memory of his wife, Erna Sondheimer-Michael.
Photograph: David Harris.

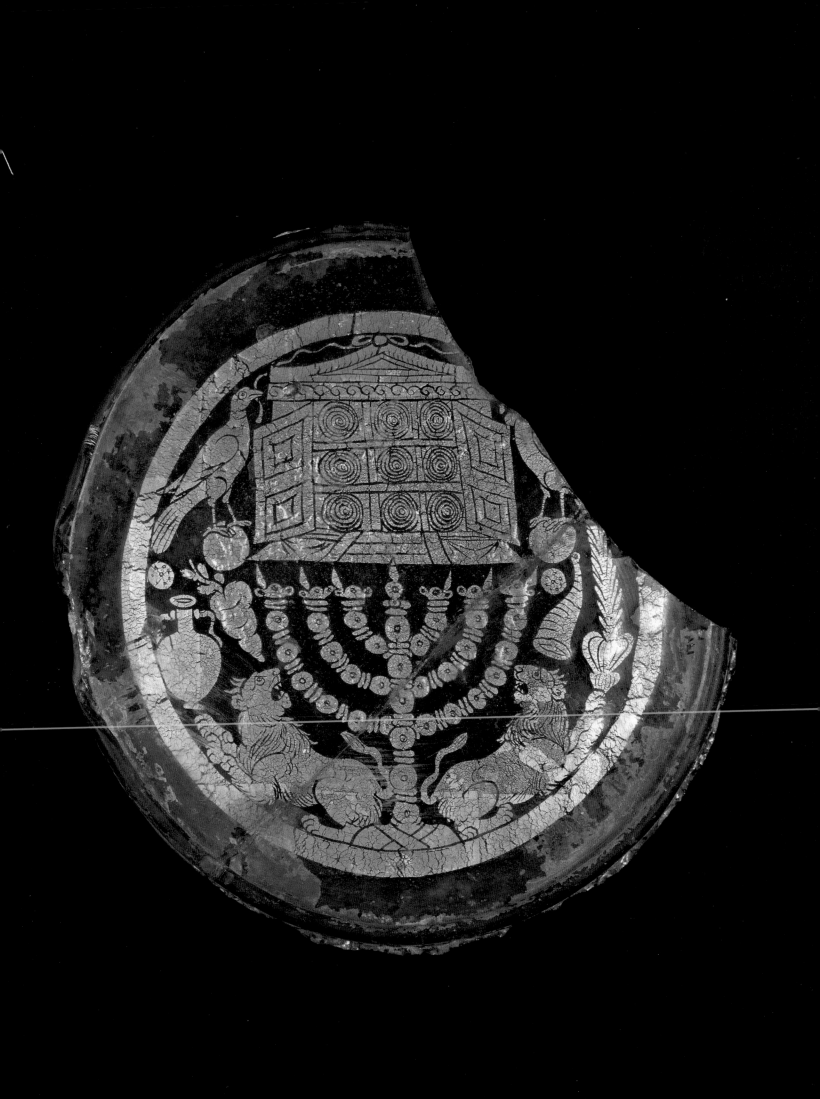

MOSAIC PAVEMENT

Beth Shean, 6th century C.E.

This panel, combining many of the symbols frequently found in Jewish art of the Byzantine period, comes from the mosaic floor of a synagogue, excavated at Beth Shean in the north of Israel, where it was placed in front of the apse. In the center of the panel is a Torah ark, shown within a gabled facade supported on two large columns. Curtains are drawn to the side and a lamp hangs from the center of the gable. Within the facade are two smaller columns supporting an arch enclosing an upward radiating conch shell. An embroidered and tasseled curtain suspended from rings closes off the space between the columns. Flanking the facade are two tall menorahs, each accompanied by a shofar and an incense shovel. The menorahs stand on tripods. A horizontal bar on top carries seven conical oil lamps, probably of glass, with the wicks clearly visible inside. Various floral and geometrical designs are also incorporated. The whole scene is framed by a typical guilloche design.

After the destruction of the Temple in Jerusalem, the role of the local synagogue as a religious center grew considerably. The scene represented in this mosaic probably depicts a synagogue facade, while at the same time evoking associations with the Temple in Jerusalem. Such scenes, together with biblical themes, representations of the zodiac, and other decorative designs, can be found on many mosaic floors decorating synagogues of the Byzantine period. The Beth Shean mosaic is one of the most detailed and fully preserved examples of such floors, in which a realistic depiction is harmoniously combined with designs of symbolic character to create a colorful and pleasing carpet.

The synagogue in which the mosaic was found has some peculiar characteristics. Unlike other synagogues of this period, it does not face Jerusalem. In addition, a Samaritan inscription laid at a later stage was discovered in a room adjacent to the synagogue's main hall, calling into question the nature of the congregation that used the site. Scholarly opinion on this issue differs, and only future finds and research will enable us to determine with certainty whether the synagogue was Jewish, Samaritan, or both.

YI

Stone and glass.
9 3/8 × 14 ft (286 × 429 cm).
Israel Antiquities Authority 63-932.
Photograph: Nahum Slapak.

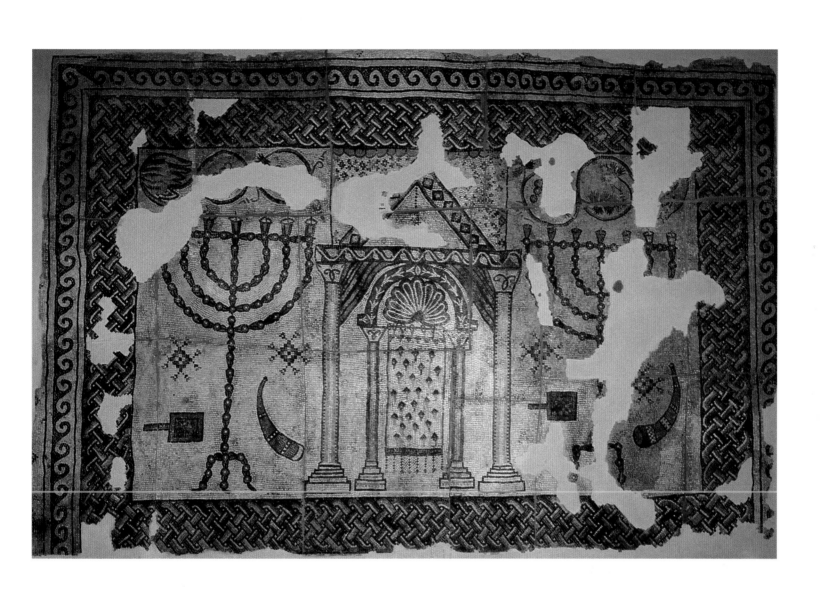

MULTIPLE-NOZZLE LAMP

Provenance unknown, 1st century C.E.

This magnificent lamp is one of the largest pottery oil lamps of the early Roman period. While it incorporates many of the Hellenistic motifs prevalent in the Jewish decorative art of the time, it is unparalleled in terms of its form and design.

The lamp is equipped with twenty-one nozzles arranged along three sides of a square. To date, no pottery lamp with such a large number of nozzles has ever come to light. In the center of the fourth side the filling hole is situated, through which oil was poured into the tube-like receptacle encircling the underside of the lamp. Above the filling hole, a ring-shaped handle is found. The lamp could either be suspended or stood on its base.

The flat upper part of the lamp is decorated in relief with laurel branches on the filling-hole side and amphorae with vine leaves and tendrils on the other sides. In the center of the square is a low dome with a rosette at its center embellished around its circumference by eleven stylized Ionic capitals, creating a harmonious architectural effect. This domed structure is a unique feature. Unfortunately, we cannot say whether the artist intended to allude to an existing building or developed this form on the basis of purely decorative criteria. Three holes in the domed part served for hanging the lamp by ropes or chains. It is clear, however, that even when the lamp was suspended, it was placed low enough so that its decorated upper part could be seen.

The lamp was made in a two-part mold and was covered with red slip. The size and splendor of this unique object suggest that it was created for ceremonial occasions.

Y I

Pottery.
H: 3 in. (8 cm); W: 13 ⅜ in. (34 cm).
The Israel Museum Collection 71.82.298.
Gift of the Friends of the Museum and Morris and Helen Nozette through the Morris Nozette Family Foundation.
Photograph: David Harris.

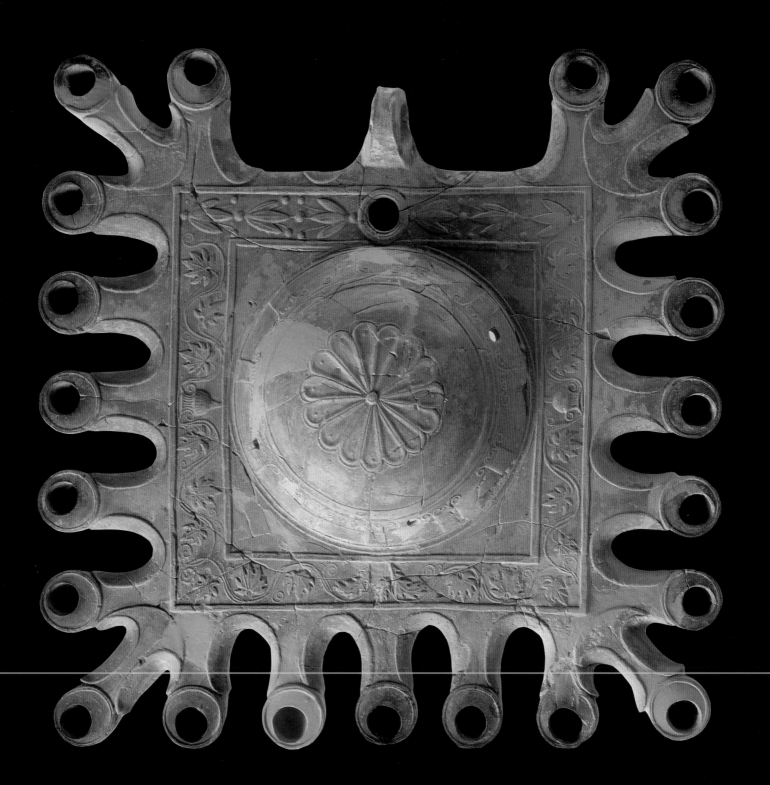

OIL LAMP WITH MENORAH

Provenance unknown, 5–6th century C.E.

Pottery oil lamps were perhaps the most common everyday object in the ancient world, appearing in the thousands and used virtually everywhere. Yet in spite of their small size and ordinary function, these vessels were richly decorated. Many of the patterns they bear are more than sheer ornamental motifs. The local oil lamps of Roman and Byzantine periods are often embellished with national and religious symbols, conveying a wealth of information about the predominant beliefs of the time. The importance of these miniature cultural documents is underscored by the fact that very few monumental expressions of Jewish culture have come to light, partly due to the biblical injunction against idol worship: "Thou shalt not make unto thee any graven image" (Exodus 20:4).

In addition to the innumerable pottery lamps, a few elaborate Jewish bronze lamps have survived. Because of their size and the skill and effort involved in their manufacture, they give even greater expression to the contemporaneous cultural trends than their pottery counterparts. This bronze oil lamp, wholly preserved except for the lid of the filling hole, is decorated on the front of its handle with a menorah, flanked by a shofar, palm branch, and citron. The rounded wick hole separated from the oil receptacle by a well-defined nozzle, the completely round body, and the shape of the handle follow well-established Roman artistic traditions. These features are rarely seen in pottery lamps, but are common in the large bronze lamps which, as a rule, had raised ring bases and sockets so that they could be placed on the spikes of elaborate metal candlesticks or candelabra.

We do not know whether this lamp was used for ceremonial purposes or whether it formed part of an affluent Jewish household. Until a few years ago, it was the only one of its kind known. In the 1980s, however, a similar lamp came to light in the excavations of Beth Shean, suggesting, perhaps, that such lamps were indeed intended for home use.

YI

Bronze.
H: 4 ⅓ in. (11 cm); L: 6 ½ in. (16.5 cm).
Schloessinger Collection, Institute of Archaeology,
The Hebrew University, Jerusalem.
Photograph: David Harris.

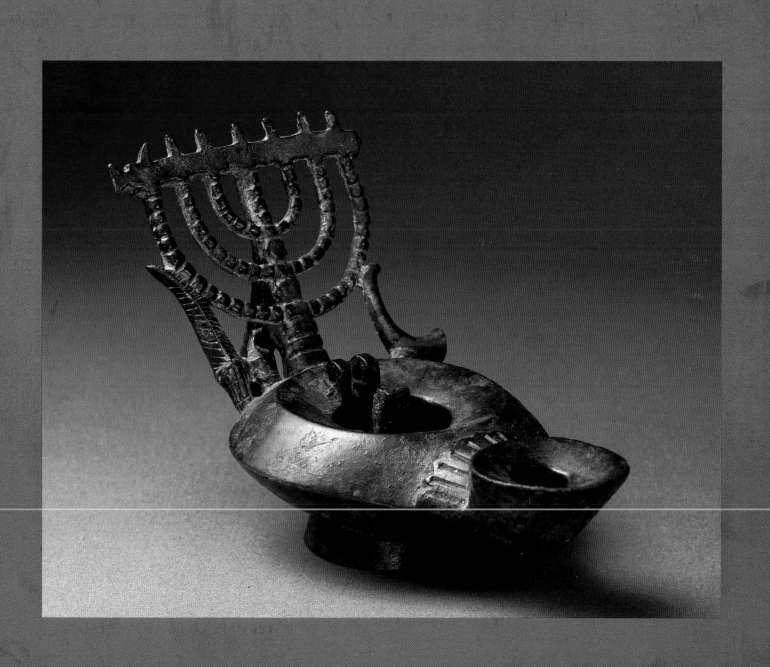

THE VITTORIO VENETO SYNAGOGUE

Italy, 1700

In 1965 the interior of the synagogue of the northern Italian town of Vittorio Veneto was transferred intact to The Israel Museum, where it has been faithfully reconstructed. It was relocated in its entirety, and even the hanging lamps were brought to Jerusalem. This synagogue was one of a group of several synagogues, Torah arks, and other pieces of synagogue furniture that were transferred from Italy to Israel between 1951 and 1969.

According to an inscription on the Ark of the Law (*Aron Ha-Kodesh*), the Vittorio Veneto Synagogue was completed on the 16th of Tevet 5461 (26 December 1700). It was used by the local Ashkenazi community for more than two hundred years. During the nineteenth century the community dwindled in size, owing to immigration to the larger cities, and by the end of the First World War the magnificent synagogue was no longer in use.

The Vittorio Veneto Synagogue originally occupied the second and third stories of a plain stone building. The women's gallery is in the upper story, running along all four walls overlooking the main hall and partitioned by a screen. Separation of men and women during prayer for reasons of modesty appears to have existed in synagogues since the Middle Ages.

The synagogue is designed in a typical northern Italian baroque style. Its plan is characteristic of the bipolar synagogues of northern Italy. The raised platform (*bimah*) for reading the Torah is situated within a niche on the western wall at the end of the hall and is flanked by the two entrance doors. The Ark of the Law, carved in wood and gilded, stands before the eastern wall. The worshippers' seats are arranged along the length of the synagogue, flanking the northern and southern walls and facing the center.

The architectural design of the ark, in particular its broken pediment, reflects the baroque style fashionable at the time, as does the glimmering surface of its carved decoration, featuring fleshy acanthus leaves and urns with flowers. The inscriptions integrated within the dense ornamentation, written in gold letters on a black background, consist of biblical and other quotations which were carefully selected to glorify their location. The uppermost frieze below the pediment reads ". . . and the glory of the Lord filled the house" (II Chronicles 7:1); along with "and ye shall give glory unto the God of Israel . . ." (I Samuel 6:5). The inscriptions on the frieze above the doors in the center read "Know before whom you are standing" (Babylonian Talmud, Berakhot 28b), and to the right and left of the doors "Look unto Me, and be ye saved, all the ends of the earth; for I am God. . . ." (Isaiah 45:22). Underneath the doors to the right is the inscription "Seek ye the Lord while He may be found" (Isaiah 55:6), and to the left "Return unto Me and I will return unto you" (Malachi 3:7). On the lower part of the ark a later inscription indicates that in the year 1842 the gilding was renovated with a donation of Isaac Kokhav, "may his soul rest in peace, and in his memory."

I F

Wood; gilt; brass; silver.
L: 34 ft (1050 cm); W: 19 ft (580 cm).
The Israel Museum Collection 194/1.
Gift of Jakob Michael, New York, in memory of his wife Erna Sondheimer-Michael.
Photograph: David Harris.

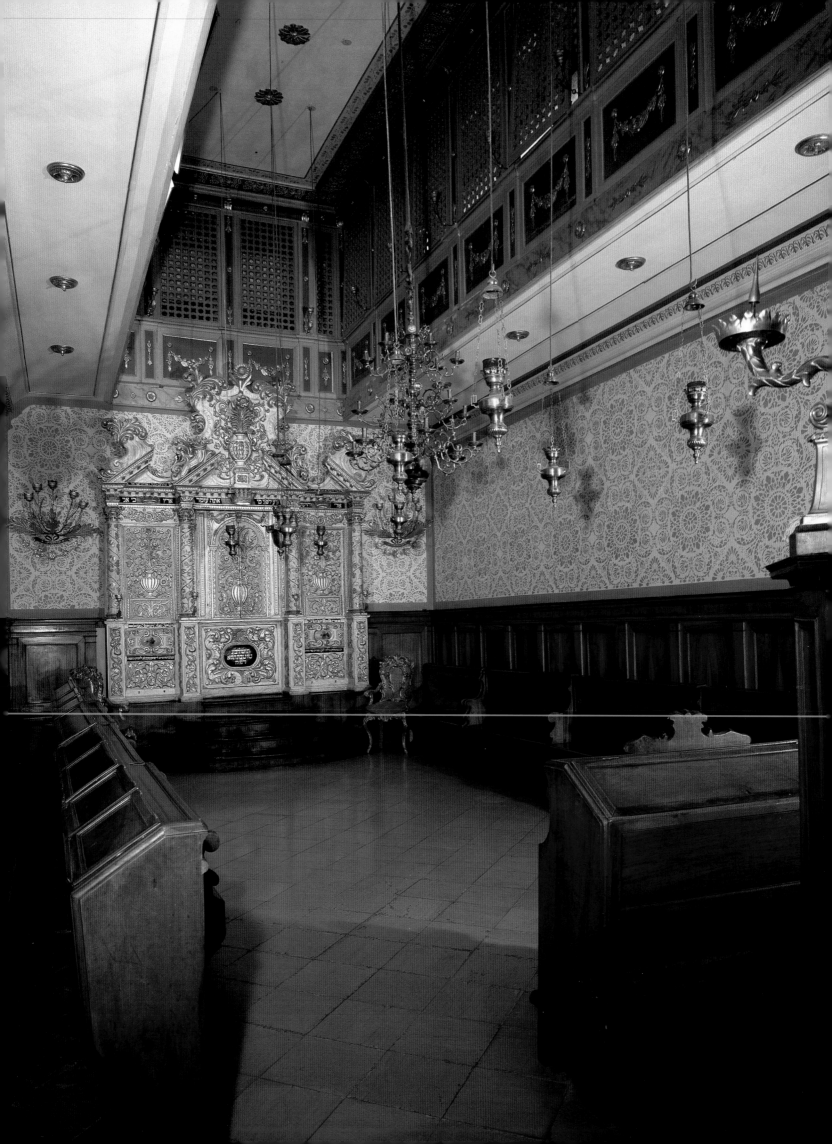

THE HORB SYNAGOGUE CEILING

Germany, 1735

Eliezer Sussmann

Between c. 1732 and 1742 Eliezer Sussmann from Brody, Ukraine, located near Lwow, arrived in southern Germany and appears to have painted the wooden interiors of at least seven synagogues. These elaborately painted synagogues were located in the towns of Bechhofen, Horb am Main, Unterlimpurg, Kirchheim, Colmberg, Rimpar, and Georgensmund. This painted ceiling from Horb am Main is the most complete surviving example of Sussmann's work. The great importance of this particular work lies in its providing unique evidence of the tradition of painted wooden synagogues in the present Bavarian region, a tradition that originated from the Polish-Lithuanian Commonwealth. There are no other complete existing examples of such work, as all painted synagogues of the Eastern European region were destroyed during the Second World War.

During his stay in Germany Eliezer Sussmann painted variations on the same motifs and in a style similar to that found in synagogue paintings of his homeland, as evidenced by old photographs of painted synagogues from the Ukraine. He covered the walls and ceilings with quotations from prayers, along with a carpet-like design of floral and animal motifs.

The Horb Synagogue occupied the second floor of a half-timbered building typical of the region. The women's gallery occupied a room annexed to the main hall, separated by a long grilled opening. The Jewish community which owned the synagogue moved in the 1860s. When rediscovered in 1908, it was unfortunately being used as a hayloft. The wall paintings on the plastered surface of the walls were partly damaged and faded. Only the wooden barrel-vault ceiling and the Torah ark were rescued in 1912, and safely transferred to the Bamberg Museum of Art where they were stored in a basement and thus survived the war.

On the eastern wall of the synagogue above the ark, Sussmann painted a curtain symbolizing the Tent of Meeting; on the western tympanum, a pair of rampant lions blowing trumpets flank the inscription from a prayer recited on Rosh Hashanah (Jewish New Year). The latter is crowned by a set of shofars, and to the right is depicted a basket overflowing with fruit and greenery reminiscent of the four species used during the Feast of Tabernacles (Sukkot), one of the most important festivals celebrated in the Temple. The longings felt by the Jewish communities of the diaspora for Jerusalem are also expressed by a stereotyped depiction of the city of Jerusalem to the left. Decorative animal motifs, including a unicorn, a deer, rabbits, and an elephant with a castle on its back, cover the ceiling. Unlike the animal motifs, all the other symbolic elements are identified by inscriptions in Hebrew. The painter proudly signed his name on the eastern tympanum, indicating the date of the building with the help of a chronogram, an inscribed phrase in which certain letters can be read as numerals to indicate a certain date.

The Torah ark is obviously older than the paintings on the ceiling and walls, and it can be presumed from one of the inscriptions that Sussmann's paintings were part of a renovation which took place in 1735.

I F

Wood, painted.
H: 7 ft (213 cm); L: 20 ½ ft (625 cm); W: 16 ft (480 cm).
On permanent loan from the Bamberg Municipality.
Reconstructed through a donation from Jakob Michael,
New York, in memory of his wife Erna Sondheimer-Michael.

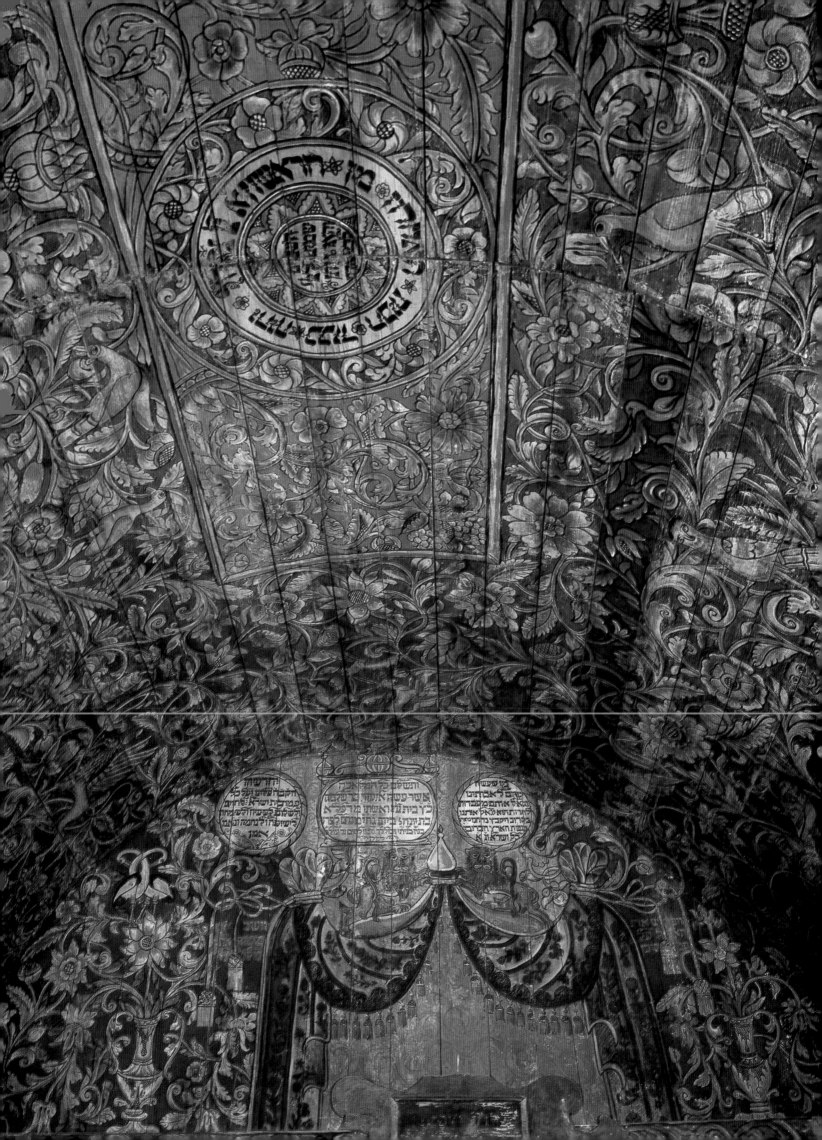

TORAH ARK DOORS

Poland, First half of the 17th century

This pair of high, narrow Torah ark doors originate from the Rema Synagogue in Cracow named for Rabbi Moses Isserles (1520–1572), known as the Rema. These rare examples represent a type of door, cast of a lead and tin alloy by Jewish artists active in Cracow during the seventeenth century. The doors bear no date, but according to the dedicatory inscription on the right door may be dated to the first half of the seventeenth century. The inscription lists the donors' ancestors back to Rabbi Isserl Lazarus, the father of the Rema, and indicates that the donors, Leib, son of Abraham, and his wife Ela, were descendants of Isaac, presumably the brother of the Rema.

The outer side of the doors is wood decorated with diagonal boards, forming a rhomboid design, and was probably originally gilt and later overpainted. The inner side of the doors is made from an alloy of lead and tin in various proportions. It consists of a plate with applied elements and contains fragments of color which may have been added at a later period. There are some traces of the original silver leaf and gilding.

On the inner side of the right door, here seen on the left, is a representation of a a seven-branched menorah with Psalm 67 inscribed along its branches. On top is a verse from Numbers 8:2 referring to the menorah. Flanking the stem of the menorah is an abbreviation of the end of verses in Psalm 67, equivalent in numeric values to one of the kabbalistic holy names for God. On the base of the lamp is another inscription from Genesis 49:18.

On the inner side of the left door, here seen on the right, is a representation of the table of the shewbread with an inscription referring to it (Exodus 25:30). Featured are the twelve loaves of shewbread, or bread of display, which were laid out on the golden table in the Temple, two of which are now missing. The loaves are arranged in two sets of six, as described in Leviticus 24:6, and on the table are two containers for the frankincense that was put on the bread.

Beneath the table on the left door is an inscription within a cartouche indicating the names of the makers of the doors. The inscription begins with a quotation from Exodus 36:4 and then lists the makers' names: "Zalman and Hayim and Mania (?) Schnitzer and Welwel KS." Two of these artists signed their names on a similar pair of doors at the High Synagogue in Cracow. The doors of the High Synagogue were made using the same technique and were decorated with the same iconographical motifs.

A close examination of these doors reveals that some of the decorative elements have been cut and resoldered. This had apparently been done so that the doors and decorative elements would fit into the narrow dimensions of the ark. This adjustment might be explained either by the possibility that the doors were transferred from another ark, or by the assumption that there existed a standard set of doors that had to be adjusted to each particular ark. That such doors were not unique is evident from existing representations of Torah arks in Poland.

I F

Alloy of lead and tin; wood; silver leaf; gilding.
H: 5 ft (154 cm); W: 1 ft (33 cm).
The Israel Museum Collection 195/5; 3704-9-64.
Gift in memory of Mattitiahu Jakubowicz of Wadowice, who perished in the Holocaust, and his wife, Haya Rivka (Helena), 1964.
Photograph: Yoram Lehmann.

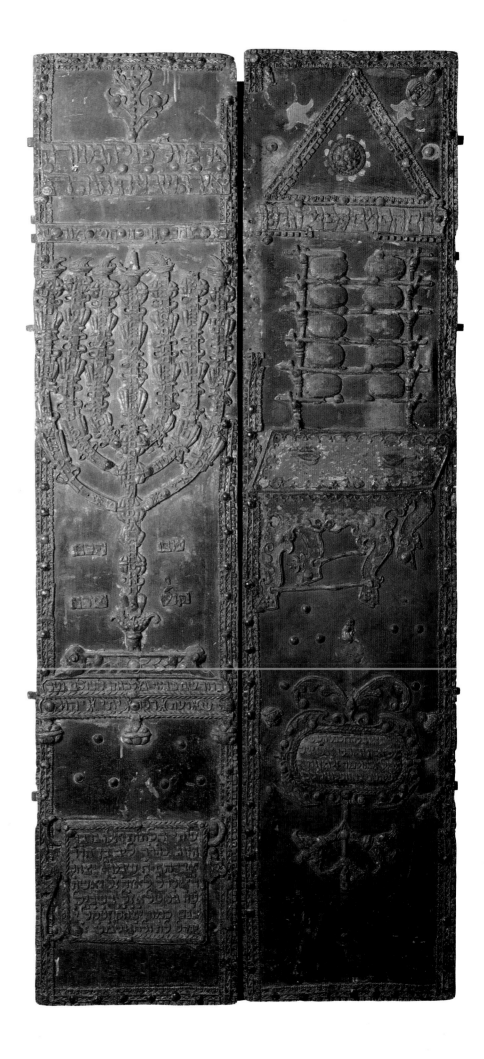

TORAH FINIALS

Yemen, c. 1900

The gilt silver Torah finials from Sanʿa in Yemen represented here are an especially luxurious and ornate pair. They are much more elaborate than the finials commonly found in Yemen, which are made of smooth brass with elongated, gently fluted bulges. Although they do represent the typical Yemenite finial structure of three differently shaped bulges, in this case the bulges are distinctly ball-, pear-, and onion-shaped. The onion shapes on top are particularly suggestive of pomegranates, from which the Hebrew term for Torah finials (*rimmonim*) originates. Finials were called rimmonim in Yemen as well. The bulging sections are worked into a sharply ribbed pattern, made of densely composed metal sheets. This creates an attractive interplay of light and shade, reminiscent of the fluted caps of several of Yemen's mosque minaret domes.

Between the three bulges an unusual type of intermediate element has been inserted, each consisting of two joined convex discs composed of a smooth metal sheet with a pattern of perforated holes, through which red and yellow fabric is discernable. The two halves of each bulb are glued together with green paste visible at the junction.

On the upper bulbs is inscribed the name of the man who commissioned the rimmonim for his synagogue in Sanʿa, Hayim Ben Shalom Keysar. Keysar died in Sanʿa in 1918. This information gives us an approximate date of the finials' manufacture.

According to oral reports, the silversmith was the late Yehudah Giyath, famous for his exquisite craftsmanship. Similar finials are known to have been manufactured by a silversmith from the same family up until the 1940s. In Yemen, professional knowledge and secrets were passed down in a family from generation to generation.

Torah finials often reflect in their form the art and architecture of the surrounding host culture. Yemenite examples show similarity to the metal finials on local minarets and in this case, to the above-mentioned multifluted mosque domes as well. The skill of interweaving foreign stylistic influences, such as Muslim architectural features and Jewish craftsmanship, on an object serving in a Jewish religious context is demonstrated here at its best.

Torah finials were among the more precious ceremonial objects of the Yemenite synagogue. This beautiful pair was brought with special pride by Yemenite immigrants to Israel.

E M - S

Silver, gilt, repoussé, and pierced; fabric and paste.
H: 14 in. (35 cm); Diam: 2¼ in. (6 cm).
The Israel Museum Collection 147/281 A/B.
Gift of Moshe and Charlotte Green, Jerusalem and New York, in memory of their mothers, Bracha Green and Chaia Appel.
Photograph: David Harris.

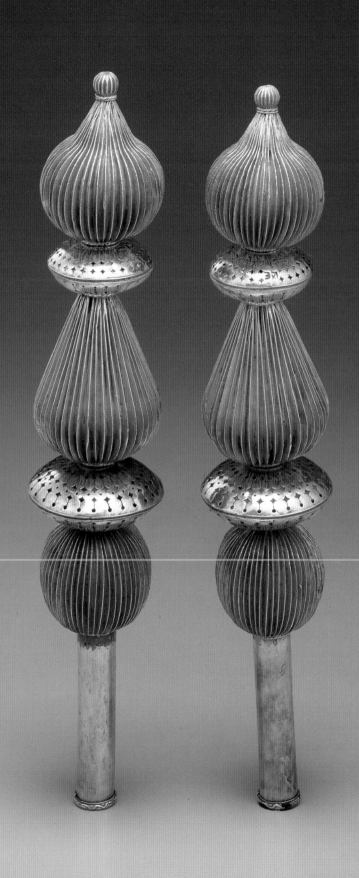

TORAH ARK CURTAIN

Germany, 1728

The art of the Torah Ark curtain (*parochet*) reached a peak during the first decades of the eighteenth century in Bavaria. Only a few pieces were preserved, while others are known to us only from photographs taken before the Second World War. These curtains were made by Jewish male embroiderers, some of whom signed their names on their handiwork. The most famous and prolific embroiderer seems to have been Elkone of Naumburg, who was active in Fürth. Another prominent embroiderer was Kopel Gans, one of whose curtains is now in the collection of The Jewish Museum of New York. All the Bavarian curtains of this type seem to have had an upper valance (*kaporet*), but unfortunately the valance of The Israel Museum curtain has not survived.

Although it obviously belongs to the group of profusely decorated Bavarian curtains of the early eighteenth century, The Israel Museum parochet is not inscribed with the name of its maker. On stylistic grounds it could perhaps be attributed to Elkone of Naumburg, whose similar parochet of 1724 is in the Moldovan Family collection in New York. All the curtains of this type are characterized by a central panel (mirror) embroidered with a rich geometric and floral design, and flanked by a pair of two twisted columns entwined with grapevines and surmounted with vases of flowers. On top, two rampant lions are supporting a crown inscribed "Crown of Torah" and flank the donors' inscription. A lower cartouche normally denotes the date and occasionally the maker's name. In its form, the parochet repeats the form of the ark, and its central mirror reflects the curtain hanging in front of the ark. At the bases of the columns the actual shape of the ark's drawers is depicted, including the rings for drawing them out.

The donors mentioned on the Bavarian curtains are in most cases a married couple, and the inscription indicates the names of both the man and his wife. The Israel Museum's parochet was donated to the synagogue by Feis Oppenheim of Kaub and his wife Rechle, daughter of Baruch Rheinganum, who are known to have lived in Mannheim, in Baden. In the *Memorbuch* (memory book) of the Community of Mannheim, kept in the Central Archives for the History of the Jewish People in Jerusalem, there is a reference to Rechle, wife of Feis Kaub, who died in childbirth in the year 1728. The donors must have been wealthy Jews, who could afford to donate such a costly curtain to their synagogue. They appear to have belonged to a class of Court Jews who are known to have been active during that period.

Not much is known about the provenance of this parochet until it reached The Israel Museum in 1982. It seems that until the Holocaust the parochet was in the possession of the Jewish community of Sulzbach, Bavaria. A photograph taken after the war in 1947 shows the curtain hanging in front of the Torah ark of the newly built synagogue of the Jewish Cultural Community Center of Munich. In 1980 the curtain was sold at a public auction in New York.

I F

Velvet, silver thread embroidery, raised appliqué.
L: 6 ½ ft (200 cm); W: 5 ft (140 cm).
The Israel Museum Collection 152/211; 57.82.
Gift in memory of Asher and Kate Judith Angel, London, by courtesy of their grandchildren.

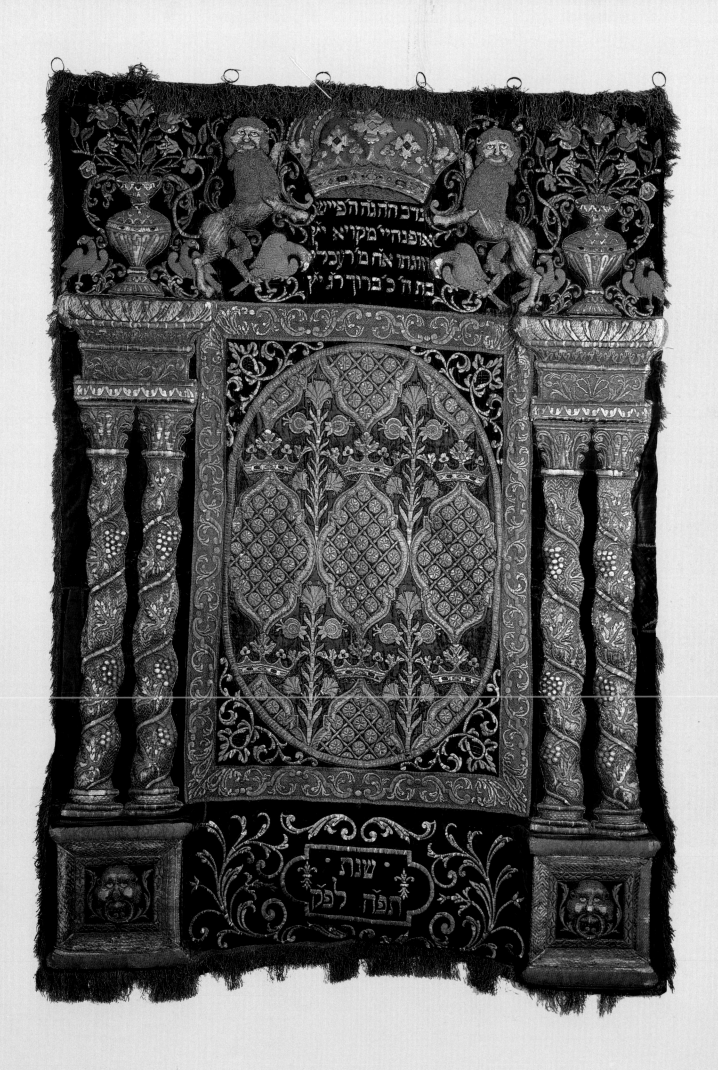

TORAH ORNAMENTS

Italy, 17th–19th century

In 1619 the Italian rabbi and writer Leone Modena wrote *Historia de'Riti Ebraici*, relating the various customs of the Jews. In describing the synagogue objects he wrote: "If the Owner of the Book [the Torah] be able, he has the ends of the Staves which come out beyond the Parchment, which they call *Hez Hayyim* covered with silver in the shape of Pomegranats [sic] (which for that reason they still call *Rimmonim*) Bells, or some such thing; at the top is a Coronet of Silver, which either goes round about them, or else half way and hangs before them. This Crown they call *Hatara* or *Cheder Toza* [sic] [*Keter Torah*] and all this work varies to the Customs of the Place or of the particular Family of the Owners."

Modena's account conveys the richness of ornamentation characteristic of Italian Jewish ceremonial objects, which reflects the art of their surrounding culture. Although these elegant ceremonial objects date back to the era when Italian Jews were confined within the walls of ghettos, they show a great affinity with non-Jewish Italian art.

The Italian Torah scrolls are wrapped in magnificent fabrics of rich brocades, or hand embroideries, and topped with silver objects profusely decorated in the Italian baroque style. Ceremonial fabrics were often embroidered by Jewish women, and according to an Italian tradition, a special blessing for women is recited on the Sabbath and festivals mentioning their contributions to the synagogue. The silver ornaments were often donated to the synagogue by individuals, who proudly inscribed their names on their donations. These objects were in most cases made by Christian artisans, although it is not impossible that there were Jewish goldsmiths employed in Christian workshops under authorized masters. Some Venetian workshops appear to have specialized in Jewish ceremonial art, and provided Torah ornaments to synagogues throughout Italy.

Venetian finials, like the ones pictured here, were normally shaped like multitiered towers and decorated with floral scrolls, palmettes, cartouches, and urns with flowers. Cast and gilt elements representing the implements of the Temple were often applied on the finials. The same cast elements were also applied onto Venetian crowns, which were shaped like open diadems and called *atarah*.

Italian Torah shields were often formed in the shape of half a crown. The shield was often functional, indicating the order of the reading of the various scrolls. It generally bore an inscription identifying the scroll as *sefer rishon, sefer sheni,* or *sefer shlishi* (the first, second, or third Torah scroll). Over the years the shield became more decorative in nature, with inscriptions appearing less often.

The Italian Torah mantle is composed of a round wooden board on top bearing two holes for the staves around which the scroll was rolled. It is especially wide and opens in the front. The Torah binder, which was embroidered to match the splendid mantle reproduced here, bears the coat of arms of the donor's family, along with a dedicatory inscription. In the binder's present condition the inscription is hardly legible, except for the date which appears to be 1655.

To avoid touching the parchment of the Torah scroll with the hands, the reader follows the text with a small pointer, traditionally fashioned in the form of a hand (*yad* in Hebrew), with the index finger in a pointing position. This splendid golden pointer from Italy is attached to a chain by which it is hung upon the scroll when not in use.

I F

Mantle: Rome, 1655 (?).
Silk, gilt silver thread embroidery.
H: 33 ½ in. (85 cm);
Upper diam: 10 in. (26 cm).

Crown: Venice, 1856.
Silver, repoussé, engraved, and cast.
H: 7 in. (18 cm);
Diam: 9 ½ in. (24 cm).

Finials: Venice, 18th century.
Silver, repoussé, engraved, cast,
and partly gilt.
H: 16 in. (41 cm);
Diam: 4 ¾ in. (12 cm).

Shield: Rome, mid 18th century.
Silver, repoussé, engraved, and gilt.
H: 4 ¾ in. (12 cm);
W: 14 in. (35 cm).

Pointer: Italy, 19th century.
Gold, repoussé, punched, and engraved.
L: 10 in. (25 cm);
Diam: 1 ½ in. (4 cm).

The Israel Museum Collection
151/77; 146/3; 147/201; 148/186; 149/202.
Mantle, finials, and pointer gift of Jakob
Michael, New York, in memory of his
wife Erna Sondheimer-Michael.
Photograph: Yoram Lehmann.

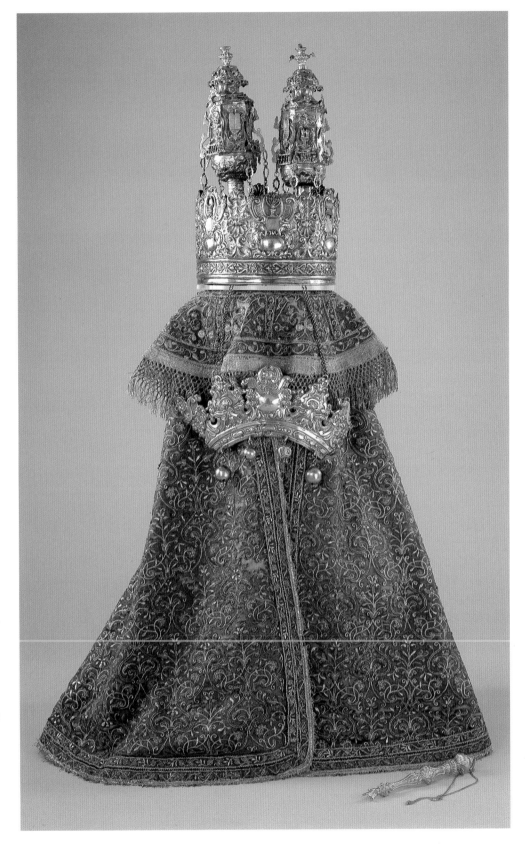

TORAH WRAPPER

Rome, 1728

I n Italy the Torah scroll was not only bound by a narrow binder but also wrapped from the outside by a wide and long strip of fabric called a *mappah*. The mappah was rolled together with the parchment scroll on its outer side to protect it from damage. Normally, it was made of simple fabric, occasionally embroidered with a dedication. In Rome, however, it was customary to decorate the central part of the mappah with the coat of arms of the family of the donors and to add a dedicatory inscription, specifying their names, the date, and the occasion of the donation. The rest of the mappah, on both ends, was made of the same material as the Torah mantle and binder of the same set. The use of coats of arms in decoration of Jewish ceremonial art was inspired by the widespread custom among Italian Christians.

The mappah reproduced here is part of a set of Torah fabrics, including a mantle and binder, all made of the same striking silk. The pattern of the brocade is of a type of brocades that were extremely fashionable at the beginning of the eighteenth century. During the raising up of the Torah scroll, after the completion of the reading, the entire congregation could see the splendid embroidered inscription with the donors' crest. The coat of arms of the Corcos family, which consists of two rampant lions supporting three "hills" with three ears of corn, also adorns the fringe of the edges of the Torah mantle. The rich collection of synagogue ornaments of the Jewish community of Rome is a testimony to the competition among the congregants of the various synagogues in adorning the Torah scrolls.

The dedicatory inscription on The Israel Museum mappah indicates that it was donated to the synagogue founded by Jews of Castilian origin (Scola Castigliana), in 1728, by the brothers Samuel and Isaac Corcos in memory of their great-grandfather Hezekiah Manoah Corcos (apparently the famous Italian rabbi who lived between 1590 and 1650),

and in memory of their father Manoah, the son of his son, and to the life of their sons, "May their Rock and Redeemer protect them." The Corcos family, originally from Corcos in the province of Valladolid, Castile, settled in Rome after the expulsion from Spain and prayed in the Castilian synagogue.

The Castilian synagogue was one of five synagogues that were concentrated in one building in Rome as a compromise with the famous papal bull of Paul IV issued in 1555 which forbade the Jews of Rome to have more than one synagogue. Housed in the same building were the Scola Catalana-Aragonese, which served the community of Aragonese and Catalan Jews living in Rome, Scola Siciliana or the French synagogue, and Scola Nova and Scola Tempio, of the Italiani, descendants of the earlier inhabitants.

I F

Velvet, gilt thread embroidery, and brocade.
H: 25 ⅓ in. (64.5 cm); L: 95 in. (240 cm).
The Israel Museum Collection 152/45; 158-1-51.
Gift of the Jewish Community of Rome.
Photograph: Yoram Lehmann.

TORAH DECORATIONS

Afghanistan, 19th–20th century

While Torah scrolls originating from different Jewish communities are essentially the same —handwritten by a scribe on parchment made from the hide of a ritually pure animal—their outer decorations differ considerably. In oriental Jewish communities the Torah scroll is traditionally kept in a wooden or metal case. The parchment scroll is rolled around two wooden rods which protrude from the top of the case. The upright case opens from the front, and the text is read without the scroll being removed from the case.

In Afghanistan the Torah is decorated with an unusual combination of three pairs of finials, consisting of a pair of flat finials, known as *ketarim* (Hebrew for crowns), and two pairs of globular finials (resembling fruit), called rimmonim. The flat ketarim are typically decorated with foliate and floral patterns. The borders of the ketarim pictured here are encrusted with multicolored beads and decorated with bells. These are placed on the wooden rods protruding from the case. The other two pairs of finials are set on wooden mounts attached to the top of the case, in front and back. They are also decorated with floral and geometric designs and have bells which hang from various points on the body, stem, and apex.

This peculiar decorative combination of six finials is unique to the Jewish communities of Afghanistan and eastern Persia, where many Afghan Jews originated. In 1839 the Jews of Meshed, a town in northern Persia, were forced to convert to Islam by zealous Shiites. After their forced conversion, the Islamized Jews of Meshed continued to practice Judaism in secret. Many found refuge in neighboring countries, particularly in Afghanistan. Thus, during the nineteenth century, the Jewish communities of Afghanistan were largely composed of Meshed Jews. These Jews revitalized the cultural life of the local communities and brought to Afghanistan the traditions of northeastern Persian Jewry, including their unusual ceremonial objects.

The round cloth which is placed between the finials is called a *malbush* (the Hebrew word for garment) by the Afghan Jews. It is a fine piece of colored silk, woven in the Ikat technique (threads dyed according to a specific pattern prior to warping on the loom so that the color outlines are not sharply defined) and is purely decorative in function. It has been noted that in some instances an inscription was embroidered on the malbush, and on the malbush pictured here, it reads "Rebekah, daughter of Miriam." In addition, colorful kerchiefs were tied to the finials and draped around the Torah case. The kerchief was used to cover the exposed parchment when the Torah was not actually being read (for example, during the blessings recited before the readings), and to prevent direct contact between those handling the Torah and the scroll itself. The use of kerchiefs is common in other Middle Eastern communities as well.

This set of Torah ornaments, which was brought to Israel by Afghan immigrants, was traced in the course of a documentation project carried out by the Center for Jewish Art of the Hebrew University of Jerusalem.

I F

Torah case:
Wood; cotton velvet; metallic ribbons; nails.
H: 24 in. (60 cm); Diam: 11 in. (28 cm).
Lent by Moshe Na'amat, Tel Aviv.

Torah finials:
Silver, repoussé, semiprecious stones.
H: 15 in. (38 cm); W: 4 ⅛ in. (10.5 cm).
Lent by Moshe Na'amat, Tel Aviv; Ovadia Rothschild of Holon in memory of his father; and gift of Sha'arei Ratzon Synagogue, Holon.

Malbush and kerchiefs:
Silk, Ikat.
Diam: 37 in. (95 cm).
Gift of the Yeshuah ve-Rahamim Synagogue, Jerusalem.

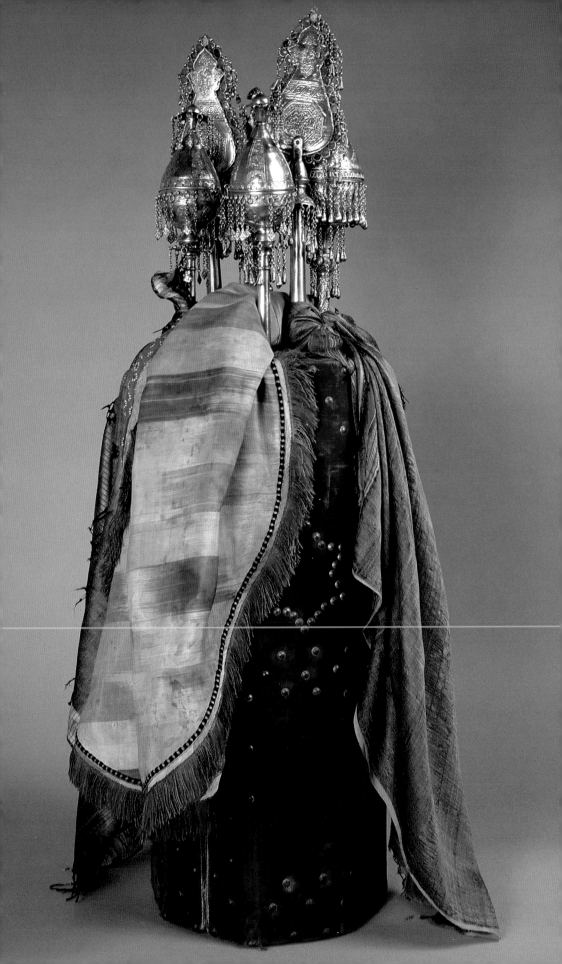

TORAH SHIELDS

Turkey, 19th–20th century

During the fifteenth century a massive influx of Jewish exiles from Spain settled in the Ottoman Empire. They enjoyed relative freedom and were able to preserve their distinctive cultural heritage, including Ladino the Judeo-Spanish language, and yet become involved in the local economy and cultural life. Their art reflects the state of contemporary Ottoman art in silversmithing, embroidery, and other crafts. Very often, distinctive Ottoman motifs, such as crescents and stars, can be observed on Jewish ceremonial objects, as on the Torah shield pictured here on the right.

Turkish Torah scrolls were usually covered by a mantle and decorated with crowns, finials, and shields. Their Torah shields had unusual geometric forms. Unlike the traditional Ashkenazi shields, they were not used to designate the scroll for the reading of the Torah, but functioned mainly as decorative and often dedicatory plaques.

The dedications would usually indicate the occasion of the donation. Sometimes these donations expressed a wish to commemorate the deceased, as can be seen on the shield pictured here in the middle. This typical round Torah shield from Izmir was originally a mirror back. When donated to the synagogue, a Hebrew inscription engraved on a silver plaque was affixed to the front. Turkish mirror backs were richly ornamented, for they were turned around to face the wall, because of superstitions. The practice of reusing everyday objects and converting them into ritual objects is well known among the Jews. This custom was especially common in Turkey, where garments, for example, were converted into Torah Ark curtains, cushion covers into Torah mantles, and as we see here, mirror backs into Torah shields.

In some places a regional style developed. In Ankara, for example, the shields often took on a round or triangular form, as can be observed here on the left. This particular shield was donated to the synagogue by a group of pious women, whose names are listed on it with great care. Although women were not assigned any role in the synagogue, they were involved in charitable activities, and it was customary for women to donate ritual objects.

I F

Silver, repoussé and punched.
From left to right:
Ankara, 1865.
H: 10 ¼ in. (26 cm); W: 14 ½ in. (37 cm).
The Israel Museum Collection 148/202; 443.69.
Izmir, early 20th century.
H: 10 ¼ in. (26 cm); W: 9 in. (23.1 cm).
The Israel Museum Collection 149/238; 730.74.
Izmir, 19th century.
H: 8 ⅔ in. (22 cm); W: 7 ⅞ in. (20 cm).
The Israel Museum Collection 148/257; 372.82.
Photograph: Yoram Lehmann.

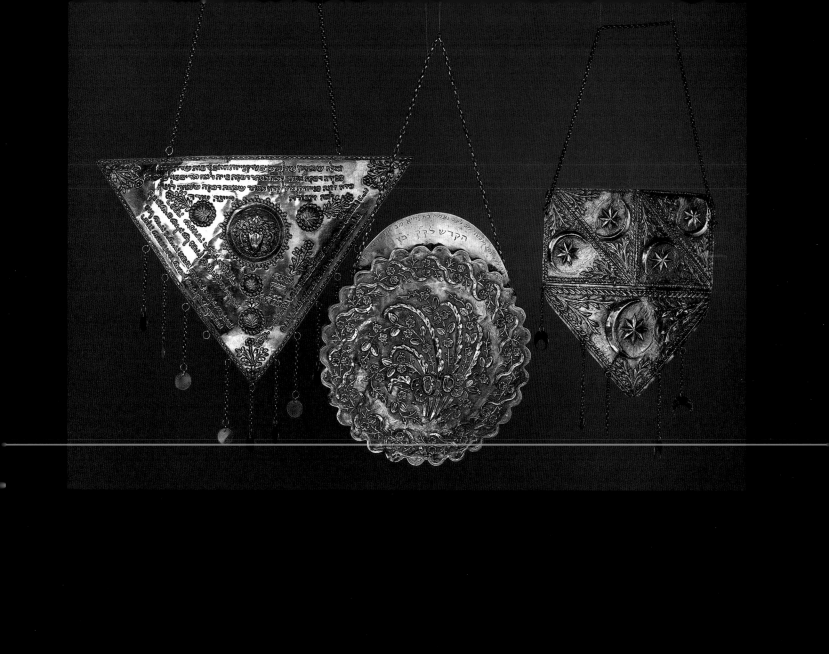

TORAH SHIELD

Germany, 1744

Johann Christoph Drentwett

The function of the Torah shield or breastplate (*tas*) was to designate which Torah scroll was to be read on a particular occasion. There are festivals on which two or even three different portions of the scroll are read—the portion of the week, the portion read on a festival, and the portion read on the occasion of a new month. Thus, in Ashkenazi synagogues, where the Torah scroll was cloaked in a mantle, this special device was hung on the front of the mantle to indicate the reading for which the scroll had been rolled beforehand. On some shields, interchangeable plaques inscribed with the word "Sabbath" or with the name of the festival were inserted into a special slot in the center of the shield. In the example reproduced here, from Augsburg, Germany, the plaque indicates that the scroll is to be read on New Year's Day (Rosh Hashanah), denoted here in abbreviated form by the Hebrew characters corresponding to the first letter of each word. A depiction of a shofar, traditionally blown on Rosh Hashanah, accompanies the inscription.

Shaped like a curtain and topped with a crown supported by two lions, this shield bears additional elements which indicate that it was a special commission. Two medallions contain fine reliefs with scenes from the life of Abraham. Above, there is a depiction of the sacrifice of Isaac, encompassed by the inscription "And it came to pass after these things, that God did tempt Abraham" (Genesis 22:1). Below, the scene shows Abraham and the three angels. The inscription reads ". . . and he stood by them under the tree, and they did eat" (Genesis 18:8). These miniature reliefs may indicate that the donor's name was Abraham. The jug in the cartouche on the bottom left may further suggest that the donor was a Levite, and what appears to be a zodiac sign on the bottom right may indicate that he was born under the sign of Sagittarius. The Hebrew inscription between the cartouches denotes the date: 1744.

Although Jews were not permitted to live in the city of Augsburg at the time when this shield was produced, it was commissioned from a well-known goldsmith from that city, Johann Christoph Drentwett (1686–1763), who is known to have made other Jewish ceremonial objects. Augsburg was an important center of goldsmithing in Germany, as evidenced by the high quality of the craftsmanship in the Torah shield pictured here.

I F

Silver, cast, repoussé, engraved, and gilt.
H: 15 ¾ in. (40 cm); W: 11 in. (28.4 cm).
Hallmark: Seling III no. 2104.
The Israel Museum Collection 148/208; HF 173.
The Feuchtwanger Collection, purchased and donated to The Israel Museum by Baruch and Ruth Rappaport of Geneva.
Photograph: Yoram Lehmann.

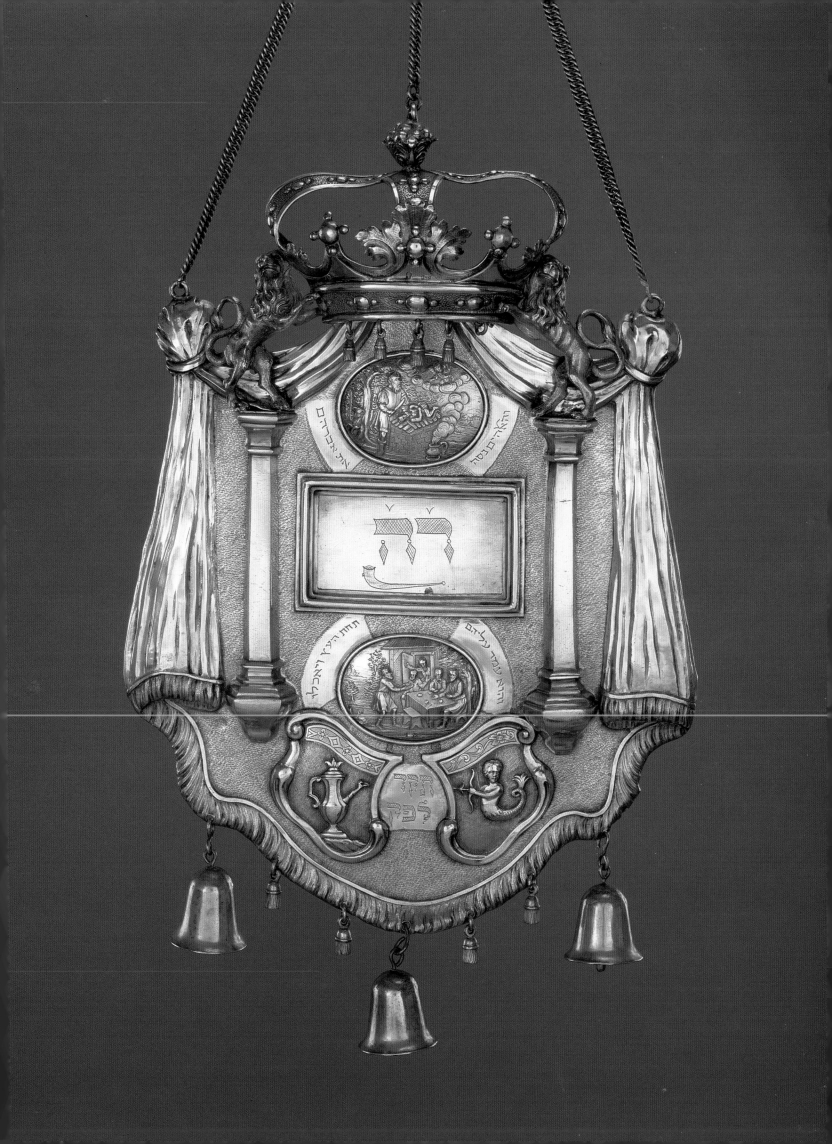

TORAH ORNAMENTS

Germany, 1904

Jacob Posen

Two dominant and outstanding Jewish women coordinated in the production of this set: Brendina Posen and Bertha Pappenheim, whose involvement and activities reflect commercial and social trends in Europe in the late nineteenth and early twentieth century.

The set was fashioned by a Jewish manufacturing firm of silver and gold, famous for their cutlery and Jewish ceremonial art which adorned almost every synagogue as well as many Jewish homes throughout Europe. The firm was founded by Rabbi Lazarus Eliezer Posen in 1834, but only in 1869 was it registered as Lazarus Posen Witwe and became particularly successful and reputable under the guidance of his widow Brendina. She employed two of her sons, Jacob and Solomon, as silversmiths. Later, other Posen family members joined the business. In 1939 the firm closed its doors for good.

The products of the firm in Frankfurt, as well as the branch in Berlin, were distributed in stores and through catalogs, and they also accepted special orders such as the set pictured here.

This set was ordered by the pioneer German feminist and social worker Bertha Pappenheim. The Hebrew dedication inscription on the back of the shield indicates that it was commissioned as a wedding gift in 1904 for Bertha's younger brother, Dr. Wilhelm Binyamin Pappenheim.

Born in Vienna to wealthy parents, Bertha Pappenheim (1859–1936) was treated early in her life by Dr. Josef Breuer, who described her as "Anna O." to his friend and colleague Sigmund Freud. Her case was regarded as a breakthrough in psychoanalysis. Bertha subsequently became famous in her own right. She moved to Frankfurt, where in 1895 she became headmistress of an orphanage. The year of her brother's marriage she founded the

Juedischer Frauenbund (Jewish Woman's League), affiliated with the German women's movement, and edited its periodicals. She went to Romania, Galicia, and Russia to aid refugees. In 1914 she founded an institute at Neu-Isenberg for unwed mothers, prostitutes, delinquents, and later for children. She translated several works into German and wrote under the pseudonym Paul Berthold. Bertha Pappenheim died shortly after being interrogated by the Gestapo in 1936. A stamp issued by the German government in 1954 bears her likeness and the words "Helper of Humanity."

Although designed in nineteenth century Neo-Gothic style, which was characteristic of all of the Posen products, the set is decorated with typical motifs of Jewish ceremonial art. Among the decorations are the Tablets of the Law with the Ten Commandments, a crown supported by two rampant lions on pillars, and a gate and dedication inscription. The construction, however, is unique. The finials reminiscent of royal crowns are lined with silk, and the short invisible cylindrical shafts are intended to be fixed on to the wood staves of the Torah scroll. Since the shield is designed as a thin and hollow closed box, both the front and the back are decorated. The dedicatory inscription is pierced on the back.

C B

Gilt silver, repoussé, cast, chased, and engraved; enamel; lapis; semiprecious stones; niello; silk.
Finials H: 6 ¾ in. (17 cm), Diam: 5 in. (12 cm).
Shield L: 7 in. (18.5 cm); W: 6 in. (15 cm); D: ⅓ in. (0.8 cm).
Pointer L: 9 in. (24 cm); Diam: ¾ in. (2 cm).
Hallmarks: Scheffler nos. 359, 631.
The Israel Museum Collection 147/342 B90.139;
148/293 B90.140; 149/266 B90.138.
Courtesy The Ari Ackerman Foundation; Moshe and Charlotte Green, New York; Meir Kaufman Estate, Jerusalem; Erica and Ludwig Jesselson, New York; anonymous donors from Switzerland and South Africa.

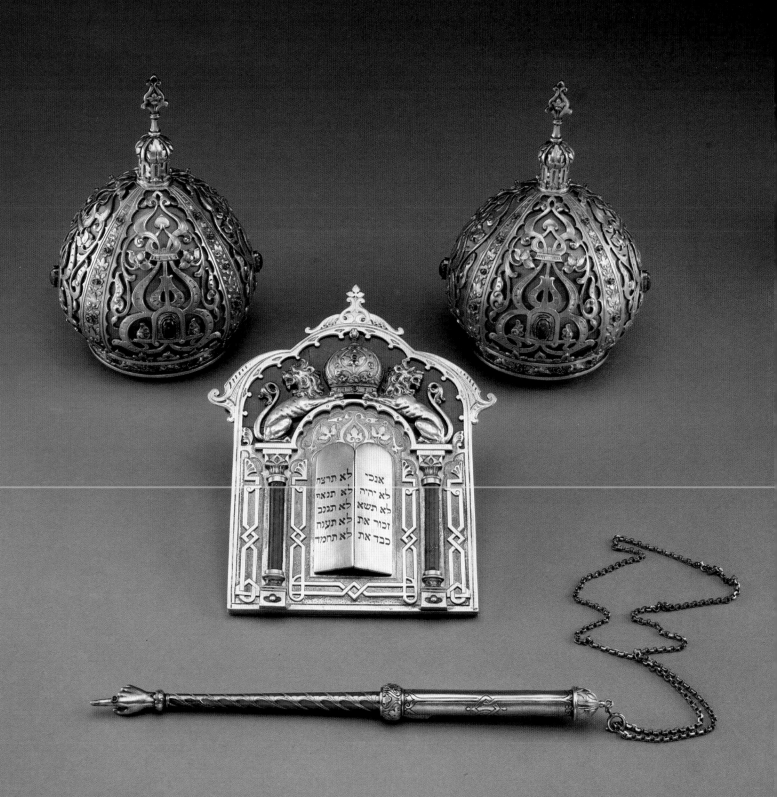

PRAYER STAND

Yemen, 18th century

This prayer stand, or tevah (*teboh* in the Yemenite idiom), is an example of the portable stand on which the Torah scrolls are placed for reading in the Yemenite synagogue. The more familiar bimah, an elevated platform on which the person who reads from the Torah stands, did not exist in Yemen.

The tevah usually stood next to the *heykhal,* a niche in the northern wall—the direction of Jerusalem—in which the Torah scrolls were kept. For the reading from the Torah the tevah was moved to the center of the synagogue. On the occasion of the festival of Simhat Torah (Rejoicing in the Law), two such prayer stands were placed together to hold all the Torah scrolls from the heykhal.

A bench which could be drawn out for little boys to stand on while reciting the Aramaic translation (*tarjum*) of the Hebrew text was an integral component of the tevah. It is interesting to note that there was no fixed age in Yemen for boys to be able to read in front of the congregation, the only criterion for this honor was that they be intellectually ready to do so.

The tevah's tilted top was always covered with a tight-fitting cloth known as a *kufiyeh,* identical to the term used for a man's head covering. It was usual for two such coverlets to be placed one on top of the other.

It is not known who crafted the ornate woodwork, as the tevah is unsigned, and it is too old to be identified by Yemenite immigrants. The high artistic quality is evident not only in the delicate carving, but also in the painting of the leaves and flowers, done in warm hues of light brown, golden yellow, and soft red on a greenish-black background.

A strong resemblance exists between the structure and motifs of the tevah and those of the Islamic prayer stand (*kursiyy*). Moreover, the style of the wood carving is reminiscent of the doorways, lattice balconies, and the plasterwork on windows of the city of San'a.

The tentative attribution of this tevah to the eighteenth century is supported by the fact that a similar style of painting has been found on a dated marriage contract as well as a Torah case from that period.

Until recently this tevah served the congregation of a small private synagogue in Jerusalem, where it was cherished with great pride and esteem as a precious legacy from the past. Its rescue from Yemen is made all the more poignant by the sheer inconvenience of transferring such a large and cumbersome object given the difficult conditions under which Yemenite Jews immigrated to Israel.

E M - S

Wood, carved, and painted.
H: 39 in. (100 cm); W: 13 ⅜ × 12 in. (34 × 30 cm).
Top: 27 × 22 ⅜ in. (68 × 57 cm).
Purchased with the help of Florence and Sylvain J. Sternberg, Jerusalem.
Photograph: David Harris.

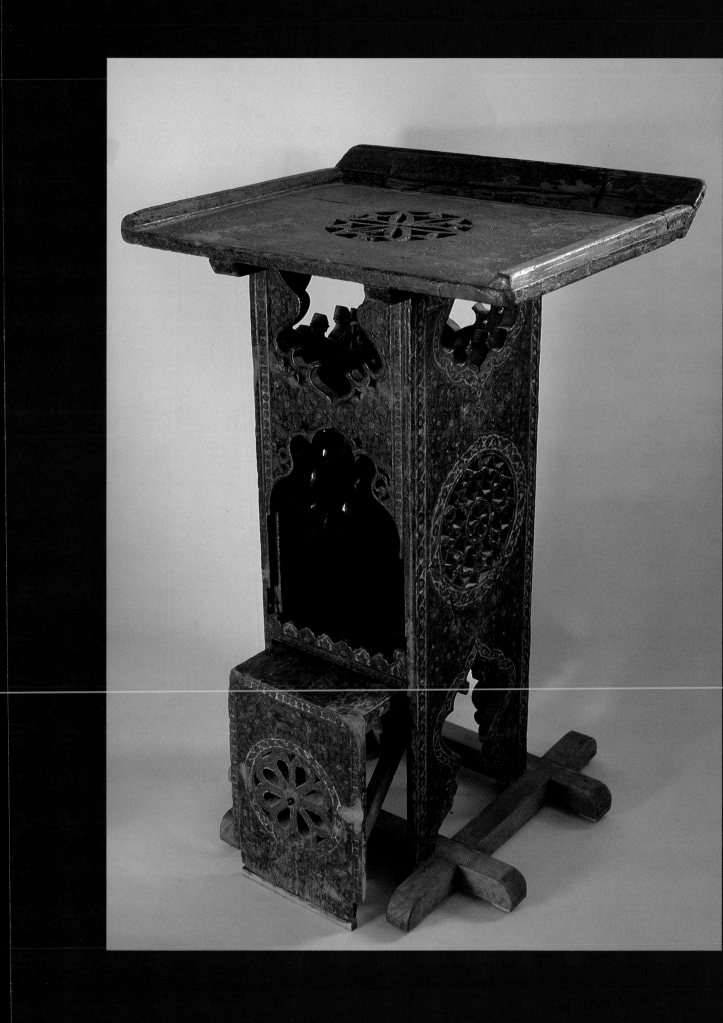

TORAH CROWN WITH FINIALS

Southern Yemen, Second half of the 19th century

This exceptional set of a Torah crown with finials from Aden, with its unique shape, is one of very few remaining of its type. It is similar to the crowns which are known to have decorated the Torah cases kept in the ark of the great synagogue of Aden, Magen Avraham.

The crown is composed of two domes soldered together, with two cut openings for the insertion of the body of the finials. The finial knops (ornamental knobs) are then screwed on to the body. At the top, a third detachable knop-like finial completes the unusual structure of the crown. This combination is unique to Aden. The geometric and floral decorations were stamped from ready-made patterns on to the flat silver sheet before it was hammered into its dome shape. Apparently, the Hebrew inscriptions were also added at this point.

Aden, situated on the major trade route between the Far East and the West, has been an important port city since ancient times. Jewish settlement there dates back to at least the tenth century, and by the late fifteenth century the community had already grown into a flourishing cultural center, encouraging the immigration of Jewish traders. By the beginning of the nineteenth century the Jewish community had dwindled to about 250 people. With the inception of British rule in 1839, however, Jews were granted equal rights in Aden. The city once again became a popular destination for Jewish immigrants, primarily from inland Yemen, but also from India, Iraq, Egypt, and even Europe, significantly increasing the Jewish presence. The exposure to Western influences, coupled with the assembly of a heterogeneous population, caused the Jewish community of Aden to develop differently from the inland Jewish communities of Yemen. Nonetheless, the Jewish populace maintained a predominantly religious character, living in a quarter of the city composed of only five streets, but housing at least seven synagogues.

According to an inscription, this Torah crown was dedicated by Moshe Hanoch Ha-Levi, a well-known figure in Aden, whose family probably originated from Izmir. He had his own private synagogue in which the prayers were conducted according to the Sephardi rite.

Another interesting feature of this crown is the combination of biblical quotations taken from Exodus and Psalms along with those extracted from the prophecies of Malachi, Isaiah, and Ezekiel. In Aden, Jewish ceremonial objects were produced only by Jewish silversmiths, as can be attested to by their knowledge of Hebrew and the Bible. This traditional Jewish occupation was gradually abandoned as Jews became more involved in trade towards the turn of the century. The ornamentation of this set reflects a typically Adenite combination of southern Yemenite style combined with foreign motifs. The inspiration from which the silversmith derived the crown's unusual structure is still a puzzle, and the influences may have come from neighboring countries such as India, Ethiopia, and even Somalia. In this sense, the set mirrors the eclecticism of the port city of Aden as well as what was once a vibrant Jewish community.

The Torah crown set was traced by the Center for Jewish Art, The Hebrew University, Jerusalem.

DRD

Silver sheet, repoussé and stamped.
H: 16 ⅛ in. (41 cm); Diam: 14 in. (35 cm).
The Israel Museum Collection 146/73; B92-1542; 147/353; B92-1544.
Purchased through a donation of the Weisz children in memory of their father David Weisz.
Photograph: Yoram Lehmann.

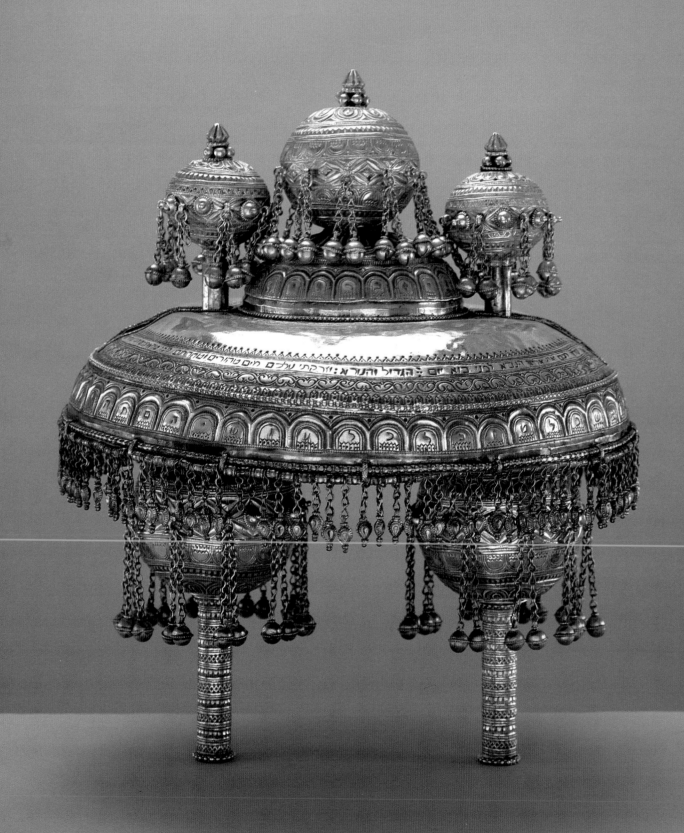

BIRDS' HEAD HAGGADAH

Southern Germany, c. 1300

The so-called *Birds' Head Haggadah* derives its name from the images featured in the manuscript. Most of the human figures are depicted as having birds' heads with pronounced beaks. Some figures also have short pointed animal ears. All male adults in the manuscript wear the conical "Jew's hat," which was compulsory for Jews in Germany from the time of the Lateran Council in 1215. In addition to the birds' heads, other methods distorting human faces such as blank faces, heads covered by helmets, and a bulbous nose are employed in the manuscript.

The phenomenon of distorting the human face, familiar from other Ashkenazi Hebrew illuminated manuscripts of the thirteenth and fourteenth centuries, is somewhat enigmatic. Both animal and bird heads, in place of human faces, were employed by artists who illustrated medieval Hebrew bibles and prayer books (*mahzorim*). Although various explanations for this curiosity have been offered, they are often controversial, and scholars have yet to provide an answer to this intriguing mystery. The practice of distorting the human face may have arisen from the growing asceticism among the Ashkenazi Jews of the period and their strict observance of the biblical prohibition against creating graven images.

Prominent medieval rabbis dealt with the problem of depicting human figures in their writings. Rabbi Ephraim of Regensburg (died c. 1175) permitted the flat painting of human figures, provided that they did not have human faces. In the early fourteenth century, depictions of "a body without a head" are referred to by Jacob bar Asher (died 1340), a rabbi and codifier of religious laws.

The *Birds' Head Haggadah* is the earliest illuminated Ashkenazi haggadah to have survived as a separate book. It is richly illustrated in the margins with biblical, ritual, and eschatological scenes. The pages reproduced here depict the preparation, pricking, and baking of the matzah, the unleavened bread eaten on Passover.

The scribe's name appears to have been Menaḥem, as he marked the letters of his name in the text. He was the same scribe who copied the Leipzig *Mahzor* (festival prayer book) around the year 1300. The Leipzig *Mahzor* is somewhat similar to the *Birds' Head Haggadah* and also features figures with heads of birds.

The haggadah was in the possession of Ludwig and Johanna Marum of Karlsruhe, Germany, until the Nazi epoch.

IF

Parchment, pen and ink, tempera; handwritten.
11 × 7 ½ in. (27 × 19 cm).
The Israel Museum Collection 180/57; 912-4-46.
Photograph: Moshe Caine.

<div dir="rtl">

ארק לראות את עצמו ·
כאלו הוא יצא ממצרים
שנ והגדת לבנך ביום ההו
ההוא לאמר בעבור זה
עשה יוי לי בצאתי ממצרי"
לא את אבותינו גאל
הקבה בלבד אלא
אה אותנו גאל עמהם זה
שנ ואותנו הוציא משם
למען הביא אותנו לתת
לנו את הארץ אשר נשבע
לאבותנו" &

</div>

<div dir="rtl">

להתבקמה וגם צרה לא
עשו להם ·
מרור זה שאנו אוכלין על
שום מה על שום שמררו
המצריים את חיי אבותינו
במצרים שנ וימררו את
חייהם בעבודה קשה בחומר
ובלבנים ובכל עבודה בשדה
את כל עבדתם אשר עבדו
בהם בפרך
בכל דור ודור חיב

</div>

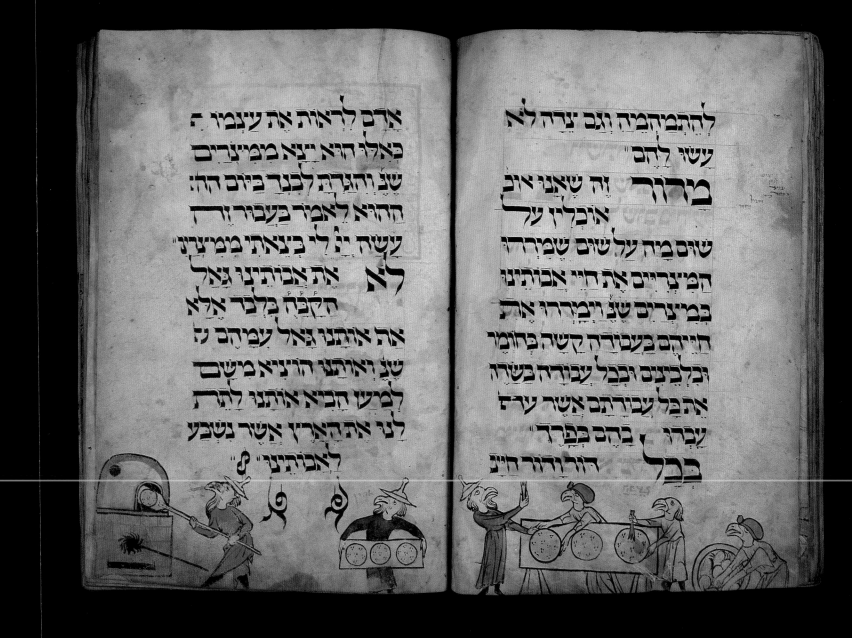

SASSOON SPANISH HAGGADAH

Spain, c. 1320

The *Sassoon Spanish Haggadah,* as it is known, is one of some twenty Spanish illuminated haggadahs which survived the expulsion of the Jews in 1492. The provenance of the haggadah can be traced to Solomon ben Joseph Carmi (Cremieux?); later, it was owned by David Solomon Sassoon (1880–1942) of London and Letchworth. In 1975 the haggadah was auctioned at Sotheby's on behalf of the Sassoon family and acquired by the State of Israel to be deposited in The Israel Museum.

The colorful and rich decorative style of this manuscript points to a Catalan origin towards the first half of the fourteenth century, and it has tentatively been dated to c. 1320. Written on parchment in square Sephardi script, the haggadah displays a blend of local and foreign stylistic influences such as the Spanish Gothic grotesques framing the margins, the elongated figures betraying a French influence, and the coloring and design of the floral scrolls, recalling Italian manuscripts of that period. Sundry additions to the haggadah indicate that it was in continual use. At some stage for example, the song "Had Gadya," probably composed in the sixteenth century, was written into the originally empty arcades, and the contours of some of the figure drawings were retraced in black ink. Additions such as the Italian censor's signature, dated 1687, also testify to the peregrinations of the manuscript.

Some of the texts of the haggadah are written in double-columned pages within twin arches, some supported by playful Gothic-style caryatids, squatting figures, and grotesque images. Interspersed with the text throughout the haggadah are numerous illustrations of biblical passages and motifs connected with the Passover festival, some of which are quite literal. The phrase "And he went down to Egypt," for example, is illustrated by a depiction of a man descending a ladder.

The splendor of the *Sassoon Spanish Haggadah* evinces the flourishing Spanish Jewish communities, who generally lived in harmony with their Christian neighbors. Richly illuminated haggadahs of this type belonged to wealthy members of the Jewish community who had close connections with the court. Impressed by the splendid Latin codices in the royal library, they no doubt wished to emulate these in their own manuscripts. Moreover, at the beginning of the fourteenth century Jewish merchants, physicians, and astronomers in contact with Catalan aristocracy must have been familiar with local artistic trends and would have demanded their inclusion in the manuscripts they commissioned. All this is reflected in the Sassoon haggadah artist's masterful assimilation of non-Jewish decorative elements, both local and foreign.

I F

Parchment, pen and ink, tempera and gold leaf; handwritten.
8 ¼ × 6 ½ in. (21 × 16.5 cm).
The Israel Museum Collection, on deposit
from the State of Israel 181/41; 583.75, fol. 86.

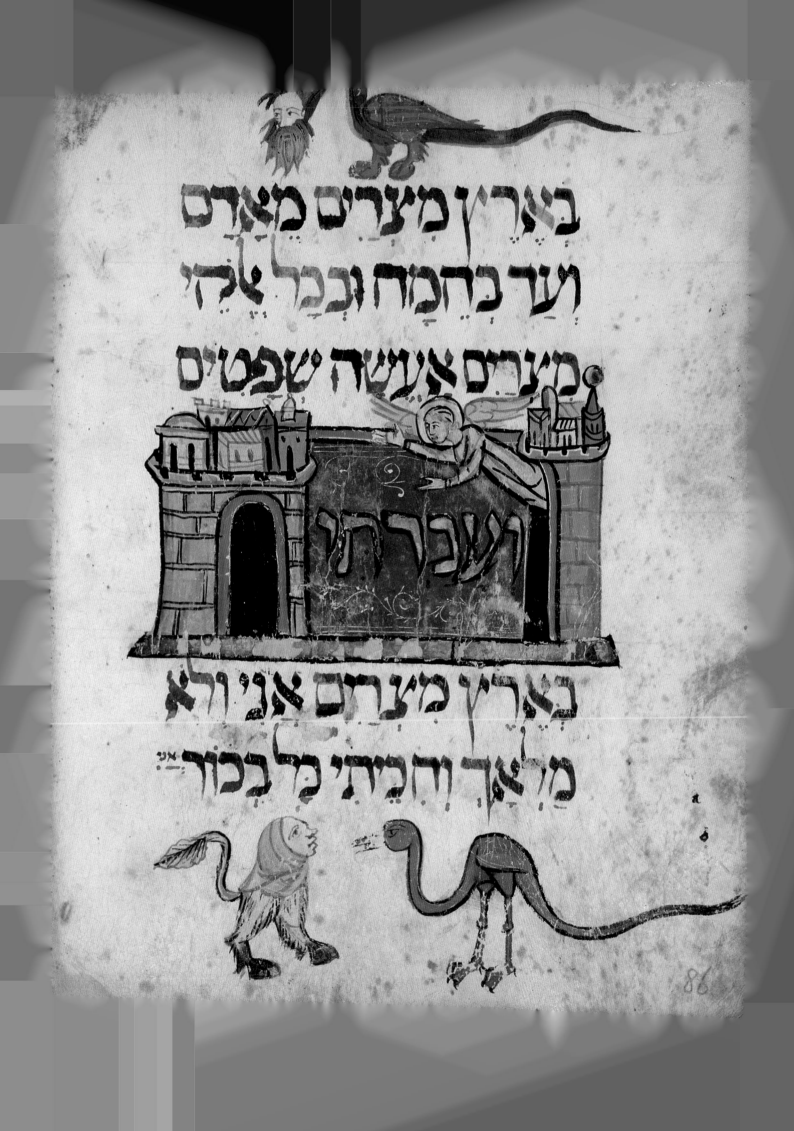

בְּאֶרֶץ מִצְרַיִם מֵאָדָם

וְעַד בְּהֵמָה וּבְכָל אֱלֹהֵי

מִצְרַיִם אֶעֱשֶׂה שְׁפָטִים

וְעָבַרְתִּי

בְּאֶרֶץ מִצְרַיִם אֲנִי וְלֹא

מַלְאָךְ וְהִכֵּיתִי כָל בְּכוֹר

THE ROTHSCHILD MISCELLANY

Northern Italy, c. 1450–1480

The *Rothschild Miscellany* is one of the most magnificent Hebrew illuminated manuscripts in existence. Almost every one of its very thin, refined parchment leaves is richly decorated with colorful miniatures and marginal paintings in tempera colors and in gold leaf. The page reproduced here is from the prayer book and shows the initial word panel for the prayer "The soul of every creature," praising God for the creation. The illustration in the margin depicts a seated man reading from a book.

The book assembles thirty-seven literary units, meticulously copied both in the main body and in the margins of the page. In terms of subject matter as well as other aspects, the text in the margins generally follows the main text. The composition includes biblical books, a prayer book for the entire year, books on *halakha* (Jewish law), ethics and philosophy, *midrash* (a genre of rabbinic literature) including historical legend, and even belles-lettres, light, entertaining literature, mostly of a secular nature. It is obvious that the miscellany was carefully planned with regard to the selection of works and its layout.

The manuscript appears to have been written by one main scribe, except for the first part, comprising three biblical books (Psalms, Job, and Proverbs), which were apparently written separately by another scribe and added to the main book at a later stage before its decoration. The text was written in square and semicursive script and contains no scribal colophon to identify the scribe. The name of the patron who commissioned this sumptuous codex, however, is found in the book. His name was Moses ben Yekutiel ha-Kohen, and it is incorporated within the prayer *mi she-berakh* (invocation of God's blessing on those called upon to take part in the reading of the weekly portion of the Torah). He may have been a wealthy Jewish banker of Ashkenazi origin, who settled in northern Italy not long before commissioning this magnificent work.

The profusely illuminated volume was decorated by Christian artists, apparently in the workshops of Bonifacio Bembo and Cristoforo de Predis. As there is no uniformity of style in the manuscript, it is clear that several artists were engaged in the illumination. It seems probable that after the writing of the text was completed, the different quires were distributed among various artists and their apprentices for decoration. Various Hebrew and Latin models were used for the illustrations, including tarot cards. In some cases, Christian subjects were adapted to a Jewish theme.

The manuscript, which belonged to the Rothschild family library in Paris, disappeared during the Second World War, reappearing after the war when it was offered for sale in New York.

I F

Vellum, pen and ink, tempera and gold leaf; handwritten.
8 ¼ × 6 ¼ in. (21 × 16 cm).
The Israel Museum Collection 180/51, fol. 103a.
Gift of James A. de Rothschild, London.
Photograph: David Harris.

שלוחת וחסבו מקרב ירחי מלוליות ▪ ומזק טן מזחה לכתולבוחתהטע פם כאר כריווחבבמי ליויטם יודך
להובת יא במערוחתן זא ▪ ▪ הב אידנו יין לחוט טו בעלי עבה ▪
עם הקהל יכל וו־ מין הוא המזוק ליוחר שיוו־ מזו ▪ וחמזו מיר־ פ שם הט ווחדי המו נזל נזל לוואחנוו

ואיך לבו מבשול יחי טלום בזיך

נשלוה באדם בוחיד ▪ למעו אחי ורעי אדברה בא ע
שלום בך ▪ למעו ביה ראה אדינו אבקשה וטוב ברזין ▪
עוד לעמד יהן יא וברך את עמה בשלובם ▪

"קריט יהם ▪"

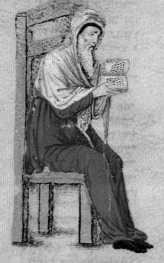

פל חי תברך את שמך יא אהינו וריח כל בשר תפארו ותרבים זכרך
מלפנו המיד ▪ מין העולם וער העולם אתה רא ▪ ומבלעריך אין לבו ▪
מלך גואל ובחטריע בורדה ובריו המפרנס ומריחם בבל עח צרה ▪ וז
ריבוקה ארן מ לבו ברך אלא אפה ▪ אלהי הרא טונים ▪ והאחרובים ▪
אלה בל בריוה ארון כל דורות המהולל הבי הדל בתשבחות המבוהג עולמו
בהסד ובריותיהי ברחמים ▪ ריא לא יבוא ▪ ולא רטן המעורר ישיבים

PRAYER BOOK OF THE RABBI OF RUZHIN

Eastern Europe, End of the 15th century

The siddur of the rabbi of Ruzhin is a prayer book for personal use containing daily, Sabbath, and festival prayers, including a Passover haggadah and *Pirqe Avot* (Sayings of the Fathers). Written in square Ashkenazi script the text covers a small part of the page, leaving relatively wide margins for illuminations and illustrations. The decoration of the siddur consists of initial-word panels to the various prayers in different designs and techniques. Some of the initial-word panels have additional marginal decorations, and some are accompanied by full border decorations of thick design with foliage and animal motifs. Only the haggadah is richly illustrated. It includes ritual representations, such as the search for the *hametz* (leaven), as well as some biblical scenes including the crossing of the Red Sea.

When the siddur was acquired by the Bezalel National Art Museum in 1951 from the Friedman Family of Buhusi, Rumania, it was known to have been in the possession of the great Hasidic leader, Rabbi Israel Friedman (died 1850) of Ruzhin, located southeast of Kiev. The rabbi of Ruzhin, the son of Rabbi Shalom Shakna, lived in great luxury and unusual splendor. It is therefore fitting for him to have possessed this splendid manuscript. Two inscriptions in the siddur reveal a chapter of its history: they indicate that at some time the prayer book belonged to the Hasidic leader Avraham Dov of Ovruch, who lived in Safed, Eretz Israel, and who survived the 1837 earthquake while praying in a synagogue which was destroyed. These inscriptions lead to the interesting conclusion that the prayer book originated in Europe, at some time made its way to Eretz Israel, and was again returned to Europe before being acquired by The Israel Museum.

As the manuscript has no scribal colophon, its date and place of origin are unknown. According to some textual peculiarities, it seems plausible that it was used in Eastern Europe, probably in Poland, and that it was written in that same area. The clue to the origin of the prayer book is provided by the text of *Sefer Haminhagim* (Book of Customs) of Rabbi Isaac Tyrnau, which is included in the margins of the book. Being one of the only two versions of *Sefer Haminhagim* that have survived in manuscript form, it indicates the names of places in Poland, Silesia, and Posen, and mentions some customs that are specific to Poland. The assumption that the book probably originates from Poland, possibly in the vicinity of Cracow, and was written between 1480 and 1500, can be supported by the style of the decoration. It is among Polish illuminated books that the closest similarities to the style of the foliage borders seem to be found. As for the style of the figures, as only the haggadah includes representations of human figures, it is very likely that the artist used a south German haggadah as his model and was influenced by its style.

I F

Parchment, pen and ink, tempera, and gold leaf; handwritten. 7 ¼ × 6 in. (185 × 145 mm).
The Israel Museum Collection 180/53; 3026-12-51.

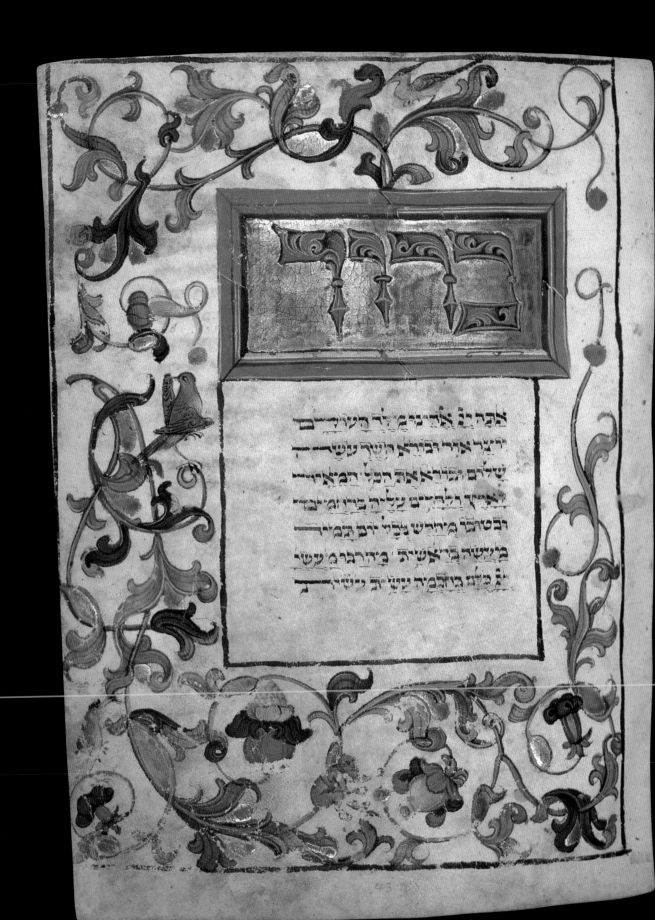

אתה יי אלהינו מלך העולם
יוצר אור ובורא חשך עשה
שלום ובורא את הכל המאיר
לארץ ולדרים עליה ברחמים ובטובו
מחדש בכל יום תמיד
מעשה בראשית ביראם עשה
בולם בחכמה יתן לב לשי

GRACE AFTER MEALS MANUSCRIPT

Moravia, 1727

Nathan of Mezeritz

This miniature manuscript belongs to a group of similar eighteenth-century Hebrew books of blessings, hand-written and hand-painted on parchment. All of these manuscripts were made for private use and were often presented as personal gifts. Some of them belonged to women, as indicated by dedicatory inscriptions and by the inclusion of specific prayers for women. This particular volume bears no dedication, but since it contains a special prayer in Yiddish to be said before the kindling of the Sabbath lights, it appears to have been made for a woman, perhaps as a gift from a groom to his bride.

This work must be considered to be part of the phenomenon of the revival of Hebrew manuscript illumination in the eighteenth century, which took place long after the invention of printing and the wide acceptance of the printed book. The small Grace after Meals (*Seder Birkat Ha-mazon*) manuscripts, undoubtedly expensive, were objects of luxury for a new class of wealthy Jews. The illustrations that depict men and women performing various religious duties are genre scenes portraying the lives of the upper-class Ashkenazi Jews. The figures wear fashionable clothes and are shown in richly decorated surroundings.

The book reproduced here was written and painted by Nathan, son of Shimshon of Mezeritz, in Moravia, where the revival of manuscript production began. He was a rather prolific scribe, and a number of his manuscripts exist in public and private collections around the world. He is known to have been active between 1723 and 1739 and to have written at least seven Passover haggadahs, two books for the New Month (*Rosh Hodesh*), and two other Grace after Meals manuscripts which are now in private collections in Paris and in New York. The Israel Museum houses a haggadah by Nathan of Mezeritz written in 1732. All of his manuscripts include colorful illustrations and display a similar recognizable style. From the colophons of his books it may be inferred that at some point he reached Holland and worked in Rotterdam.

The *Birkat Ha-mazon* manuscript of The Israel Museum featured here includes the Grace after Meals, followed by a group of shorter benedictions for recital on a variety of other occasions (*birkot ha-nehenin*). Thereupon follows the prayer said before retiring to sleep at night (*keri'at shema*), four Psalms, and the blessing recited at the appearance of the new moon.

The small book is profusely illustrated, especially in the section containing the "blessings on various occasions." The illustrations that accompany these blessings are arranged two on a page and are inscribed with instructions in Yiddish, indicating the occasion on which the blessing is to be said. These include, for example, the blessings said upon eating fruits, smelling spices, seeing a rainbow, hearing good tidings, seeing a king, and even upon seeing exotic creatures (as defined by eighteenth-century European Jews), such as a dark-skinned person or a dwarf.

IF

Gold tooled leather binding on wooden boards; parchment, pen and ink, and gouache.
3 × 2 ¼ in. (7.4 × 5.7 cm).
The Israel Museum Collection 180/66; 674.68.
Gift of Jakob Michael, New York, in memory of his wife Erna Sondheimer-Michael.
Photograph: Yoram Lehmann.

[Top spread]

מוֹןׁ פירות דים מוֹןׁ דעֶר בויק ווֹמקפֿלין זׁמֶנֶט אֻןׁ דֻמֻט

בָּרוּךְ

אַתָּה יְיָ אֱלֹהֵינוּ מֶלֶךְ הָעוֹלָם

בּוֹרֵא פְּרִי

הָעֵץ

מוֹןׁ זֻמֻןׁ דים מוֹןׁ דער עֶרדן ווֹמקפֿן זׁמֶנֶט דִיזׁ

בָּא"אֱ"מֶה בּוֹרֵא פְּרִי הָאֲדָמָה

מיבֶר טאֶעֶקדינֵי פירות זׁמֶנֶט וון דים ברכה

בָּא"אֱ"מֶה הַנּוֹתֵן רֵיחַ טוֹב בַּפֵּירוֹת

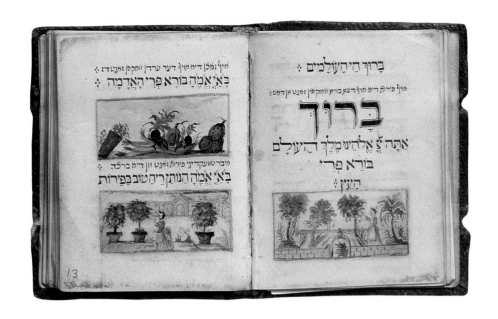

[Middle spread]

וֹמֶןׁ מייר פֿאֵר מיןׁ מֶטֻיטיק קֻמֶר בּיים גֻט זׁמֶנֶט דִיזׁ

בָּא"אֱ"מֶה בּוֹרֵא מִינֵי בְשָׂמִים

מיבֶר מֻרֻ דיים רוֹזׁ וׁמֶה לֻדֶר הָמֻןׁ זׁמֶנֶט וון די

בָּא"אֱ"מֶה בּוֹרֵא עֲצֵי בְשָׂמִים

וֹאןׁ מייר מיןׁ רֶעֶנֶיןׁ בּוֹנֶיןׁ זֻיֶּבֶט זׁמֶנֶט וון דים ברכה

בָּא"אֱ"מֶה זוֹכֵר הַבְּרִית וְנֶאֱמָן בִּבְרִיתוֹ וְקַיָּם בְּמַאֲמָרוֹ

וֹמֶןׁ מייר הֶערֶט דִינֶדֶרין עֶרֶט לֵייטֶרןׁ זׁמֶנֶט אֻןׁ דֻמֻט

בָּא"אֱ"מֶה שֶׁכֹּחוֹ וּגְבוּרָתוֹ מָלֵא עוֹלָם

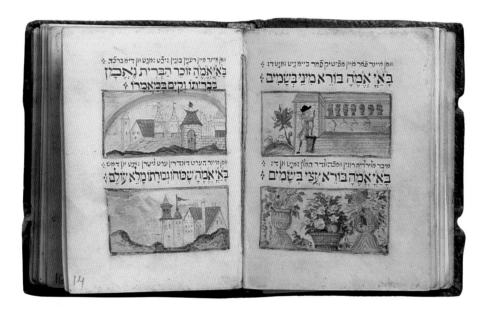

[Bottom spread]

וֹמֶןׁ עֶ בֻלֶנֶ דוֹזֶערֻטֵטֻ אֻמוֹ זׁמֶנֶט אֻןׁ דים ברכה

בָּא"אֱ"מֶה עֹשֶׂה מַעֲשֵׂה בְרֵאשִׁית

וֹמֶןׁ מייר מיןׁ נֻטֻ טֻווֹעֶ הֶערֶט זׁמֶנֶט וון די

בָּא"אֱ"מֶה הַטּוֹב וְהַמֵּטִיב

דֶער דם זֻיֶּבֶט ווֹלֶבֵי מוֹוֻט עֻ"וֹק זׁמֶנֶט וון דים ברכה

בָּא"אֱ"מֶה שֶׁחָלַק מִכְּבוֹדוֹ לְבָשָׂר וָדָם

דֶער דם זֻיֶּבֶט מיןׁ מֻר גֻ"ווֹעֶרןׁ זׁמֶנֶט וון דִיזׁ

בָּא"אֱ"מֶה מְשַׁנֶּה הַבְּרִיּוֹת

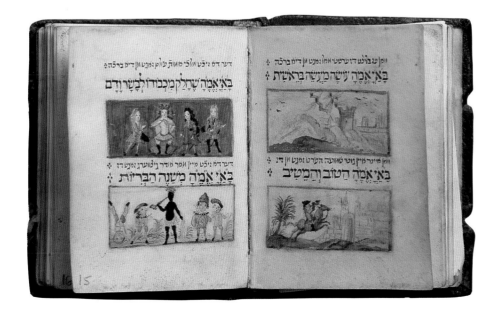

THE FIVE SCROLLS IN MICROGRAPHY

Austria, 1748

Aaron Wolf Herlingen

The master Jewish scribe, Aaron Wolf Herlingen, is known to have been employed as a calligrapher and a scribe at the Imperial and Royal Library in Vienna. In producing this single sheet, which is a masterpiece of calligraphy and scribal art, he proficiently displayed his professional talent. This type of sheet must have become popular, as he produced at least four similar sheets, two of which are preserved at the Austrian National Library in Vienna, dated 1733 and 1748; another one, dated 1755, formerly of the Sassoon Collection, was recently auctioned; and yet one more sheet is housed in the collection of the Royal Library of Stockholm.

All of these sheets are basically similar and differ only slightly from one to another. They all contain the five shorter books (*ḥamesh megillot*) of the Hagiographa or *Ketuvim,* which is the last division of the Hebrew Bible. The sheets are written on vellum in microscopic writing in different languages and scripts and are illustrated with minute vignettes. The Book of Ruth is written in German in Gothic script; the Song of Songs in Latin; Ecclesiastes and Esther in Hebrew square and cursive scripts; and Lamentations in French. Within the vignettes four minute scenes are meticulously drawn: on top is the Judgement of Solomon illustrating Ecclesiastes; to the right Solomon enthroned illustrates the Song of Songs; Mordecai before Ahasuerus adorns the Book of Esther in the middle; and Ruth and Boaz in the field illustrate the Book of Ruth to the left.

The scribe signed his name in German within the letters of the word "Osculetur" on the top right, indicating his position as a scribe in the Imperial Library. He noted the place and date of writing inside the letter "I" on the top left. He also signed his name in Hebrew within the letters of several words in the Book of Esther.

Aaron Wolf Herlingen of Gewitsch was one of the most renowned scribes of the eighteenth-century manuscript revival. Born around 1700 in Gewitsch, Moravia, he established a school of Hebrew illumination in Vienna, a city of wealthy and prominent Court Jews such as Samuel Oppenheimer and Samson Wertheimer. Herlingen, who was active until around 1760, was a most prolific scribe and produced numerous painted manuscripts as well as haggadahs and smaller books of blessings. Although he did produce a few colored manuscripts, most of his works were illustrated with monochrome pen and ink drawings which imitated the art of engraving in printed books.

I F

Vellum, pen and ink, and gold leaf.
7 ½ × 6 in. (19.1 × 15 cm).
The Israel Museum Collection 180/34.
Photograph: Yoram Lehmann.

HANGING SABBATH LAMPS

Western Europe, 18th–19th century

The kindling of the Sabbath lights inaugurates the Sabbath every week in the Jewish home. It is considered to be one of the three chief religious duties of a Jewish woman, and at dusk on Friday candles or oil lamps are lit by the women of the family.

All the variants of hanging Sabbath lamps depicted here evolved from an old type of star-shaped domestic oil lamp that was commonly used in medieval Europe by Jews and non-Jews alike. It survived among European Jews as a traditional ceremonial object for use on Sabbath and festivals, and since at least the sixteenth century has been known by its German name *Judenstern* (Star of the Jews). *Judenstern* lamps are depicted in medieval Hebrew manuscripts in scenes of Passover meals and are also found in woodcuts illustrating Books of Customs in the depictions of a Jewish woman kindling the Sabbath lights.

This particular type of hanging lamp consisted of several spouts stemming from a central oil reservoir, surmounted by a baluster shaft with a drip bowl below. Excess oil could be drained from the nozzles directly into the drip bowl by removable open ducts. The number of spouts varied greatly, from six to twelve in some examples. Although the lamps were usually made of brass and occasionally of pewter, more elaborate ones were produced in silver.

The German lamps had long spouts, and were often suspended from a saw-shaped lever from the ceiling. The lamp hung high up from the ceiling during the week, and a trammel hook was used for lowering the lamp on the Sabbath.

In Italy another version of the *Judenstern* lamp developed, consisting of shorter spouts. The elaborate Italian silver lamp seen here is richly decorated with embossed floral designs and is suspended from ornamental chains which are attached to a canopy above.

The silver lamp from England on the left is a fine example of a more sumptuous lamp. It was made by the London silversmith Samuel Hennell in 1813. This type of lamp, consisting of a deep oil container surrounded by very short nozzles, decorated with a crown on top and a cone pendant at the bottom, was typical of Dutch Sabbath lamps and must have been introduced to England by Sephardi Dutch Jews. A similar lamp was made in London in 1734 by the well-known Portuguese Jewish silversmith Abraham de Oliveyra.

I F

From left to right:
England, 1813.
Silver.
H: 57 in. (145 cm).
The Israel Museum Collection 117/156; 30.68.
Gift of Jakob Michael, New York, in memory of his wife Erna Sondheimer-Michael

Italy, 18th century.
Silver.
H: 31 ½ in. (80 cm).
The Israel Museum Collection 117/136.
Gift in honor of Edgar and Libby Fain from their friends.

Germany, 18th century.
Brass.
H: 15 ¾ in. (40 cm).
The Israel Museum Collection 117/6.

Italy, 18th century.
Brass.
H: 21 in. (53 cm).
The Israel Museum Collection 117/174; HF 207.
The Feuchtwanger Collection, purchased and donated to the Israel Museum by Baruch and Ruth Rappaport of Geneva

Germany, 18th century.
Brass.
H: 19 in. (48 cm).
The Israel Museum Collection 117/3.
Photograph: Yoram Lehmann.

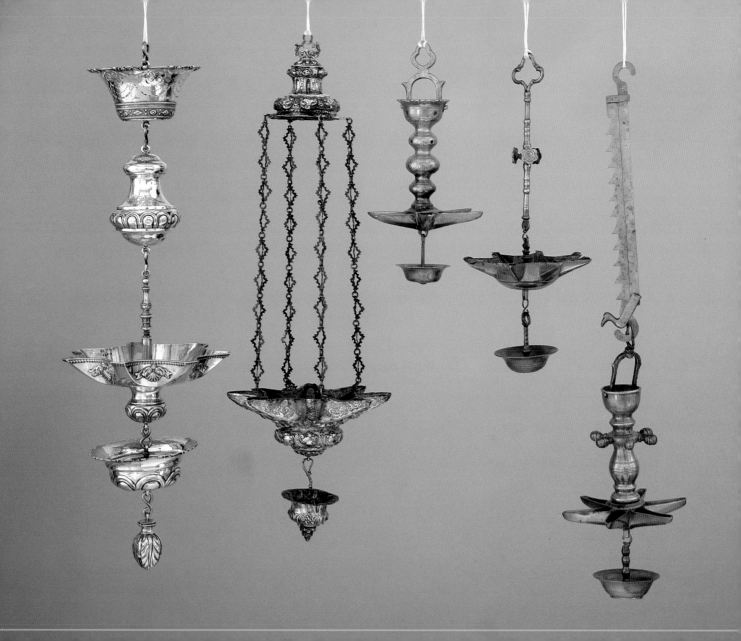

SABBATH CANDLESTICKS

Israel, 1988

Zelig Segal

Zelig Segal (1933–), a contemporary Israeli Judaica artist, creates original designs and generates a "new" Jewish art. His work focuses primarily on traditional ritual objects, which he envisions in an innovative manner, sometimes introducing an original iconography.

According to tradition, a Jewish woman kindles at least two Sabbath lights every Friday night. His candlesticks entitled "In memory of the destruction of the Temple" consist of three bent cylinders, one of them truncated and without a socket. Being a sculptor, his approach is entirely formal. Using abstract minimal means, he gives expression to religious and spiritual ideas. In this case, he used polished silver to convey a feeling of sanctity and spirituality.

In other instances, Segal prefers to deliberately leave the material in its rough form, not burnished or polished in any way, in order to stress the formal elements and the idea they are intended to express. Another recurrent device in his attempt to grant the object an expressive dimension is his use of tearing and cutting. Hence, his memorial candle holder, made of a torn metal plate, is a direct expression of the pain of bereavement and the accompanying custom of the mourner's tearing of the garment. He uses the tearing motif in his series of alms boxes as well, where tearing is associative with poverty. The same motif is also featured in his works on paper.

Zelig Segal was born in Jerusalem, grew up in a religious family, and was educated in an ultra-orthodox Jewish day school and yeshiva before he studied at the Bezalel School of Arts and Crafts. His approach to religious objects is entirely unconventional. When he designs an object, he discards all traditional conventions and develops his idea as if he were the first to treat the subject at hand. Ignoring conventions, he creates alternative designs which are no less sophisticated and stimulating both in essence and in form.

I F

Silver, bent and fabricated.
7 × 1 ½ in. (17.5 × 3.8 cm).
The Israel Museum Collection 116/210; B90.482.
Purchased through the Eric Estorick Fund.
Photograph: Nahum Slapak.

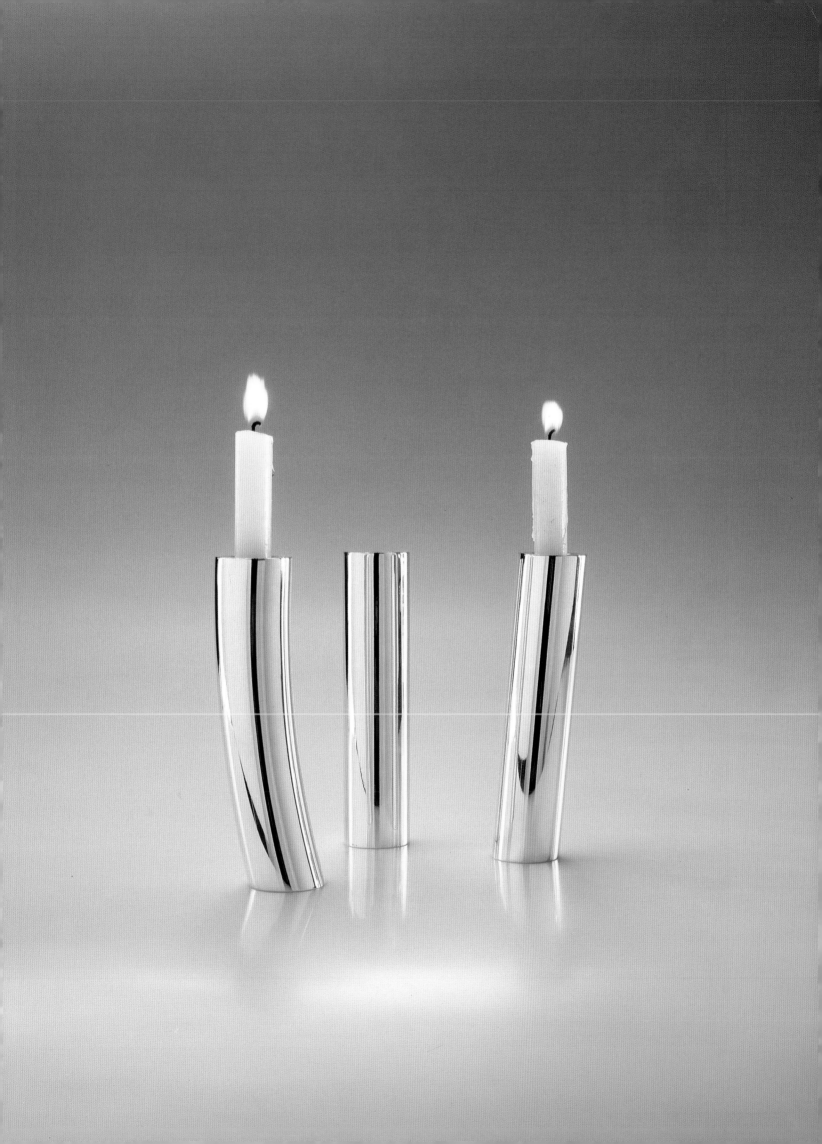

SPICE BOXES

Europe, 18th–19th century

Spice boxes are used in the havdalah (literally meaning "separation" or "distinction") ceremony that marks the end of the Sabbath. This ceremony symbolizes the passage from the seventh day of rest to the six working days of the week: passage from the sacred to the profane. The havdalah is a very ancient rite, described in the Talmud. The ceremony is generally performed at home by the master of the house and includes blessings recited over a cup of wine, spices, and a burning candle. After the benediction over the spices ("Blessed are You, God our Lord, King of the universe, creator of various kinds of spices."), the spices are passed around to be smelled by all members of the family. In his work entitled *Mishneh Torah,* Maimonides noted that spices are used to revive the soul, saddened by the end of the Sabbath.

During the Middle Ages, Jews commonly used wild myrtle (*hadas*) leaves for the benediction over spices. In later periods, however, other kinds of aromatic exotic spices brought from the East were employed. The spices used in the havdalah ceremony were kept in beautifully decorated containers. The earliest documented record of the use of a special vessel for spices is found in an Ashkenazi rabbinical source from the twelfth century. Only in the fifteenth century was this receptacle given the name *hadas,* in reference to the traditional myrtle branch.

The earliest extant spice boxes date back to the sixteenth century and are in the form of towers. One older tower-shaped vessel, which appears to be a thirteenth-century bronze Spanish spice box, is in The Victoria and Albert Museum in London. Although the tower shape of the spice box seems to have reached central Europe by way of Spain, the form may have been influenced in Europe by similar vessels made for Christians for religious purposes. As Jews were not admitted into the goldsmiths' guilds, spice boxes were often commissioned from non-Jewish goldsmiths. There is evidence that Christian goldsmiths recorded Jewish spice boxes among their works, using the Hebrew term slightly differently and calling them Jewish *hedes*.

The most common form of spice box in Europe, until quite recently, has continued to be the tower shape, possibly inspired by the prevalence of architectural forms in the design of contemporary European silver work. Spice boxes were also created in other forms, including various animals, fish, and flowers, although these were more unusual. In the examples pictured here, one spice box is shaped like a sunflower: the tiny holes perforated in the flower allow the smell of the spices, which are kept inside, to come out. In the unique spice box shaped like a bird perching on a plant, the spices are contained within the bird, whose wings are hinged and can be opened to insert the spices. The very fine example next to it shows a spice box designed like a pear tree, with a man trying to pick the fruit with the help of a stick. The largest pear on the tree is pierced and contains the spices.

I F

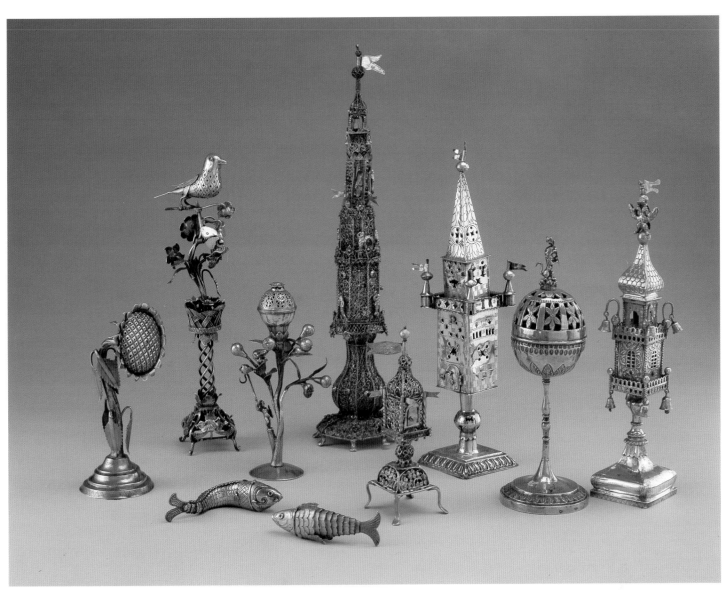

From left to right:
Russia or Poland, 19th century.
Silver.
H: 7 in. (17.9 cm); W: 2 ¾ in. (6.9 cm).
The Israel Museum Collection 124/549;
98.86. The Stieglitz Collection, donated to
The Israel Museum, with the contribution
of Erica and Ludwig Jesselson, New York.

Poland, late 18th century.
Silver; semiprecious stones.
H: 12 in. (29.5 cm); W: 2 ⅛ in. (5.5 cm).
The Israel Museum Collection 124/364;
291-4-51.

Austro-Hungary, 18th century.
Silver, partly gilt.
H: 7 in. (18 cm); W: 2 in. (5 cm).
The Israel Museum Collection 124/261.

Central Europe, 18th century.
Silver, filigree, partly gilt; semiprecious
stones.
H: 16 in. (40.5 cm); W: 4 in. (10.5 cm).
The Israel Museum Collection 124/417;

HF 239. The Feuchtwanger Collection,
purchased and donated to The Israel
Museum by Baruch and Ruth Rappaport
of Geneva.

Cracow, Galicia, 19th century.
Silver, filigree.
H: 6 ¹¹/₁₆ in. (17 cm); W: 2 ½ in. (6.1 cm).
Silversmith: Stanislaw Westafalewocz.
The Israel Museum Collection
124/559;108.86. The Stieglitz Collection,
donated to The Israel Museum, with the
contribution of Erica and Ludwig Jesselson,
New York.

Nuremberg, Germany, 18th century.
Silver.
H: 13 in. (32 cm); W: 3 in. (8 cm).
Silversmith: Johann Conrad Weiss.
The Israel Museum Collection 124/226;
3973-5-52. Gift through the Jewish
Restitution Successor Organization, 1952.

Rome, Italy, 19th century.
Silver.

H: 10 in. (25 cm); W: 3 ⅜ in. (8.5 cm).
Silversmith: Angelo Giannotti.
The Israel Museum Collection 124/7;
166-1-51.

Austro-Hungary, dated 1817.
Silver, partly gilt.
H: 11 ½ in. (29.3 cm); W: 2 ⅜ in. (6 cm).
The Israel Museum Collection 124/363.

Front row (fish), left to right:
Germany, 19th century.
Silver.
L: 4 in. (10 cm); W: 1 ⅜ in. (3.5 cm).
The Israel Museum Collection 124/558;
107.86. The Stieglitz Collection, donated to
The Israel Museum, with the contribution of
Erica and Ludwig Jesselson, New York.

Poland, 19th century.
Silver.
L: 5 ⁵/₁₆ in. (13.5 cm); W: 1 in. (2.5 cm).
The Israel Museum Collection 124/288.
Photograph: Yoram Lehmann.

SUKKAH

Southern Germany, c. 1837

This remarkable sukkah was discovered in 1935 by Dr. Heinrich Feuchtwanger, stored in the attic of the Deller family residence in the village of Fischach, situated near Augsburg, Germany. This unique example of Jewish folk art was commissioned by Abraham Deller, apparently sometime after 1836–7.

The artist who painted this sukkah incorporated motifs inspired by both traditional German folk art of everyday scenes and Jewish religious sources. Along the walls of the sukkah one can see a genre hunting scene and a view of the village, including the synagogue and the Deller house. Five vignettes relating to the major Jewish festivals are interspersed on the walls. They depict the offering of the lamb on Passover, the giving of the Law on Shavuot, the binding of Isaac (which pertains to the Jewish New Year), the high priest preforming a sacrifice on the Day of Atonement, and the *hakkafot* (ceremonial processional circuits in the synagogue) performed on Sukkot.

The immediate model for these panels of the sukkah seems to have been a five-volume *mahzor* (High Holiday and festival prayer book), printed by Seckel Arnstein and Sons in Sulzbach in 1826. This is the only edition of the Sulzbach *mahzor* printed in which each volume opens with a copper engraving pertaining to the respective festival. Evidently, Abraham Deller owned a copy of this distinctive *mahzor,* as the five panels on the walls of the sukkah were copied directly from its engravings, occasionally with slight deviations.

The wall opposite the entrance of the sukkah bears a monumental vista of the holy sites of Jerusalem as seen from the west. Similar depictions of Jerusalem are known to have served as popular pilgrims' mementoes in the nineteenth century. The first illustration of this type appeared in a lithograph dated 1836–7. It was drawn by the Jerusalem scholar Yehosef Schwartz and distributed by his brother Hayyim, who served as the rabbi in Huerben, a township near Fischach. A copy of this work was apparently acquired by Abraham Deller, as it was reproduced almost in its entirety in his sukkah as a unified composition. The lithograph by Yehosef Schwartz thus provides the dating for the painting of the Fischach sukkah.

The sukkah was used by the Deller family until the beginning of the twentieth century when it was stored in an attic to prevent further deterioration. In fear of Nazi regulations, the sukkah was smuggled out of Germany in 1935. It was installed, facing inward against the walls of a wooden crate containing the personal belongings of the Fraenkel family of Munich, then en route to Eretz Israel. It was then presented to the Bezalel National Museum of Jerusalem and was thus saved from destruction.

N F - S

Wood; oil paint.
H: 6 ½ ft (200 cm); L: 9 ½ ft (290 cm); W: 9 ½ ft (290 cm).
The Israel Museum Collection 196/1.
Gift of the Deller Family with the help of Dr. Heinrich Feuchtwanger.
Photograph: Pierre-Alain Ferrazzini.

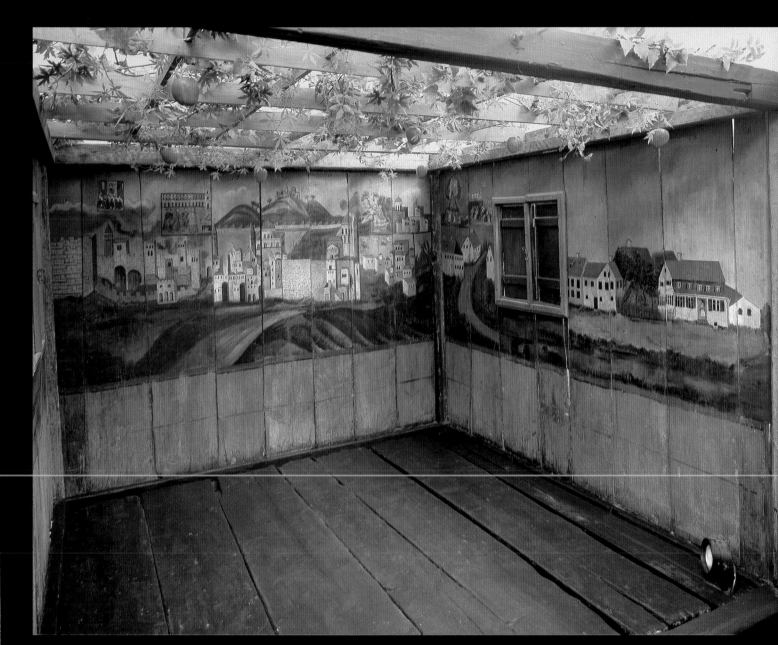

HANUKKAH LAMP

Germany, 1721

Hanukkah is celebrated for eight days, commemorating the rededication of the Temple in Jerusalem by the Maccabees (Hasmoneans), after its liberation from the Syrian Seleucids (the Greeks) in 164 B.C.E. (I Maccabees 4).

It seems probable that during the eight-day reconsecration of the Temple a second Feast of Tabernacles was celebrated, including kindling of torches at the water-drawing festival (one of the ceremonies of Sukkot), because the festival had not been held at its proper time due to the siege of the Temple by the Greeks. The more common legend of Hanukkah relates that upon entering the Temple, the Hasmoneans discovered that the Greeks had defiled all the holy oil except for one cruse, which contained only enough oil to keep the candelabrum of the Temple burning for one day. But a miracle happened, and they were able to kindle the lamp with the oil from this one small container for eight days. According to this tradition, a Festival of Lights lasting eight days was hence established. Whatever its origin, the custom of every man's kindling the Hanukkah lights was officially instituted by the second century C.E.

A Hanukkah lamp as a rule is comprised of eight lights, and in most cases, like in the example pictured here, an additional light called a *shamash,* Hebrew for servant, is added. The shamash was added for illumination purposes, as Hanukkah lights are sacred and not permitted to be used for any purpose, only beheld. This is declared in a prayer recited following the kindling benediction, which is engraved on the back wall of the lamp reproduced here.

Throughout the ages Hanukkah lamps have been made of diverse materials and in a variety of shapes. The lamp featured here was apparently crafted in Nuremberg, an important center of silversmithing in the eighteenth cen-

tury. On its back plate, within an oval embossed medallion, is engraved the prayer "We kindle these lights on account of the miracles, the victories and the wonders...," which is recited after the lighting benedictions. The text of this prayer is followed by the date 5[481] = 1721.

Flanking the medallion are two figures: Judith on the left, depicted holding a sword and the severed head of Holofernes, which she is about to hand to her maidservant on the right, waiting with an open sack in which she plans to carry the head. The story of Judith and Holofernes is related in the apocryphal Book of Judith. Since medieval times this book has been associated with the festival of Hanukkah, and depictions of the narrative are occasionally found on Hanukkah lamps. The story tells of how during the siege of Bethulia by the Assyrian commander Holofernes, Judith, a beautiful, young, and righteous widow from the city, went down to his encampment and cut off his head while he was asleep. Deprived of their commander the soldiers fled, and the city of Bethulia was saved.

Popular tradition associated Judith with Judah the Maccabee and his father Mattathias, the founder of the Hasmonean dynasty. It is therefore not surprising to find the figure of Judah as a soldier decorating the top of the back wall of this Hanukkah lamp.

I F

Silver, repoussé and engraved, partly gilt; semiprecious stones.
H: 12 ¾ in. (32.4 cm); W: 10 ½ in. (26.6 cm).
The Israel Museum Collection 118/914; 362.86.
Gift of Daniela Dror, in memory of her father,
Etienne Shwovacher, Tel Aviv.
Photograph: Yoram Lehmann.

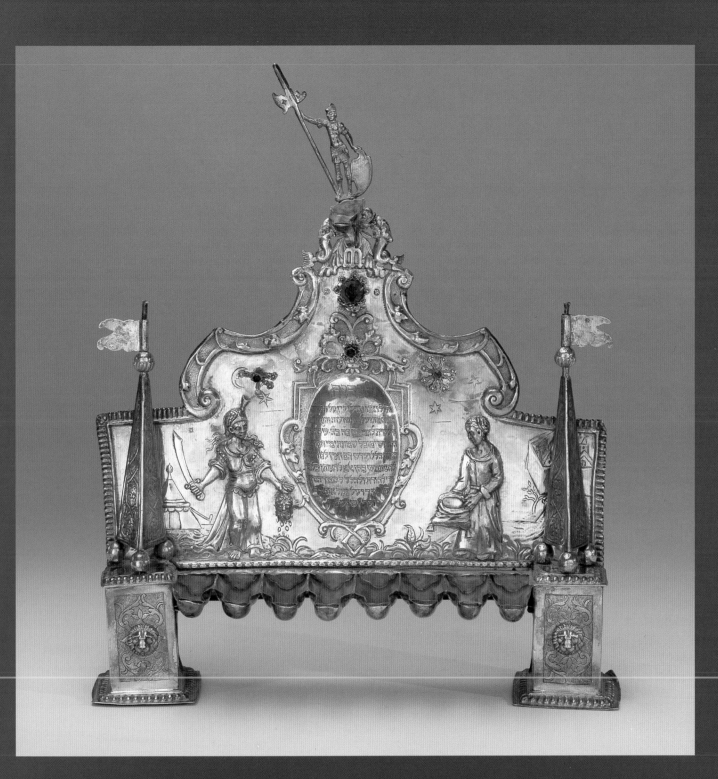

ESTHER SCROLL

Germany (?), Early 18th century

The Book of Esther is read publicly in the synagogue on the eve of the festival of Purim. A holiday of feasting and joy, Purim is celebrated in remembrance of the miracle of the salvation of Persian Jewry during the reign of King Ahasuerus (Xerxes, reigned 486–465 B.C.E.). It is customary for the text to be handwritten on a parchment scroll. Many traditions have developed around the writing of the scroll (megillah), especially concerning the listing of the names of Haman's ten sons in eleven lines, and the extension of the letter *vav* in the name of Haman's tenth son, Vaizatha, as was done in this scroll. Esther scrolls were often decorated along the borders, with printed engravings or with monochrome or painted drawings.

In this unusually lavish scroll, the text is written in round medallions within decorated and illustrated frames. The entire scroll is profusely illustrated with scenes related to the story of the megillah, some of which are based on commentaries on Hebrew scriptures (*midrash*). The illustrations are extremely lively and joyful, presenting the figures of the Purim story in eighteenth-century dress and portraying genre scenes of festive courtly banquets and musicians.

In the detail reproduced here, the round text column is encircled by a zodiac. At the outer edge of the zodiac, a man is pointing with his stick at the sign of Pisces, which is the sign of the Jewish month of Adar. According to the Book of Esther, lots were cast to determine the month of execution for the Jews, and the fatal lot fell on the month of Adar. Eventually, the plot to annihilate the Jews was foiled, however, and they were delivered from danger. Purim is celebrated on the fourteenth of Adar, and the holiday's name derives from the Hebrew word *Pur,* literally meaning "lots."

The identity of the artist who decorated the scroll is not known, but the same artist appears to have painted at least three other very similar scrolls. These are now housed in the Jewish Historical Museum of Amsterdam, in the John Rylands Library in Manchester, and in a private collection in Tel Aviv.

I F

Parchment, pen and ink, gouache painting; handwritten.
H: 10 in. (25.5 cm); L: 117 in. (297 cm).
The Israel Museum Collection 182/81; 2390-12-52.
Photograph: Yoram Lehmann.

LUSTERWARE PASSOVER PLATE

Spain, c. 1480

This Passover plate is one of a few preserved objects of Jewish ceremonial art which originated in Spain prior to the expulsion of the Jews in 1492. Shaped and decorated in a manner typical of contemporary Spanish lusterware plates, it has a wide rim, flat bottom, and an elevated center called an umbo in the center. It is decorated with repeated motifs of gadroons and various floral and geometric designs in brownish-gold and cobalt blue. There is a hole in the brim into which a clay peg was probably inserted to keep the large dish in an upright position during one of the firings, as was customary in the process of producing large Valencian plates.

The inscription on the plate refers to the three main elements of the Passover feast: *pesaḥ* (paschal lamb); *matzah* (unleavened bread); and *maror* (bitter herb). The word seder (order) refers to the ritual meal accompanied by the reading of the haggadah which takes place on the first night of Passover. The naive mistakes in the Hebrew spelling may indicate that the plate was commissioned by a Jew from a non-Jewish craftsman who was unfamiliar with the Hebrew characters.

Although a special seder plate is mentioned as early as 200 C.E., no early examples have survived. Most seder plates known to us date from the eighteenth century onwards and are made of every conceivable material: pewter, brass, silver, faience, porcelain, and even wood. The matzot were often placed in a receptacle separate from the other ritual foods. In medieval Ashkenazi illuminated haggadahs there is often a large round plate shown on the table, probably for ceremonial use during the seder, but in medieval Sephardi haggadahs, a special wicker basket for the matzah is usually depicted. In at least one Sephardi haggadah, however, it is not clear whether the matzot are placed in a basket or a dish. It must be taken into consideration that all the above-mentioned haggadahs are from the fourteenth century, and the use of a special seder dish in Spain might have been introduced later.

I F

Earthenware.
Diam: 22 7/16 in. (57 cm).
The Israel Museum Collection 134/57; 483-12-65.
Gift of Jakob Michael, New York,
in memory of his wife Erna Sondheimer-Michael.
Photograph: Nahum Slapak.

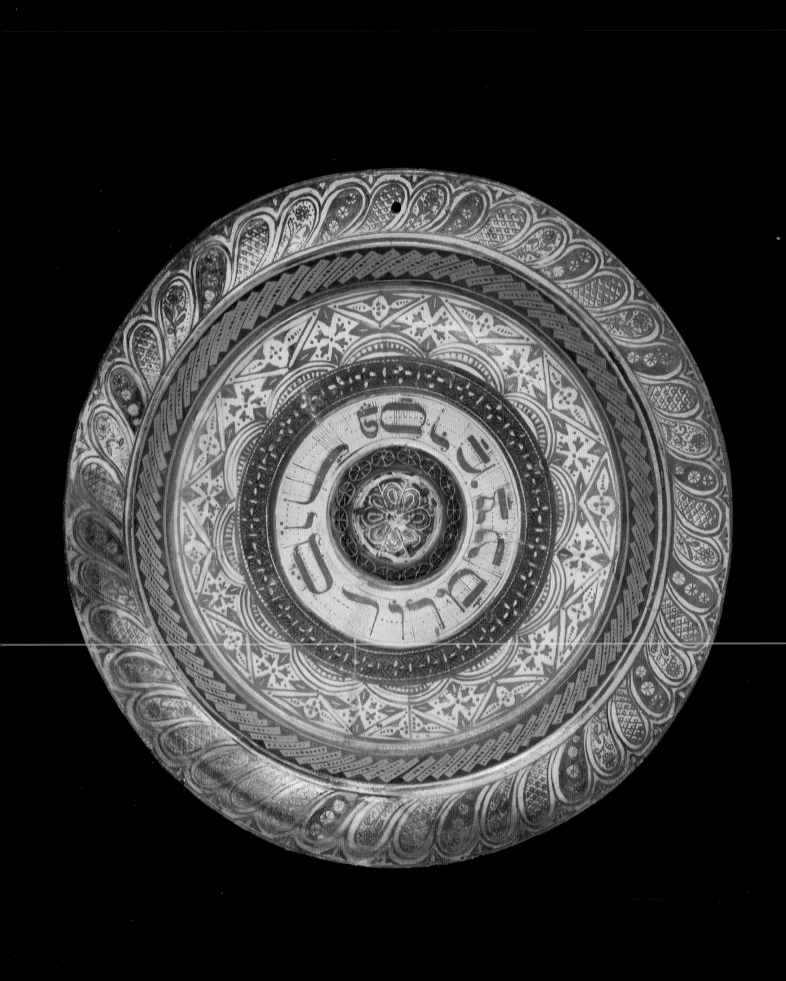

MIZRACH

Southern Germany, 18th century

A *mizrach* (literally meaning east) is a single sheet or plaque that was hung on the eastern wall in a Jewish home. It was meant to indicate which direction one is to face during prayers, towards Jerusalem. Over the years the mizrach plaques became a typical ornament in Jewish homes, often presented as wedding gifts. The word mizrach, written in large letters on these plaques, was often interpreted as an acronym formed from the Hebrew phrase "from this flank the spirit of life."

It was customary to decorate the mizrach sheet with drawings or paper-cuts. The example reproduced here is decorated with a series of scenes illustrating customs pertaining to various Jewish festivals. The watercolor drawings, executed in a naive folk style, are a valuable source of information with regard to Jewish folk customs in Germanic lands during the eighteenth century. The small rectangular panels, which do not seem to be arranged according to any chronological sequence of the Jewish calendar, depict a Jew and his family performing various religious duties on different festivals.

On the top band, beginning on the right, the festival of Sukkot is represented by a depiction of the family seated within a sukkah while a maidservant brings in a dish. The man is lifting a goblet, and a star-shaped lamp of the *Judenstern* type is hanging from the ceiling. The next drawing shows the family seated around a table for the seder meal on Passover eve. The man is shown in an exaggerated reclining position, raising a cup. His wife is holding an open haggadah, and a child is reading from another haggadah. An infant is also present, swaddled in a cradle. In the left panel, in an illustration of the festival of Shavuot, one man is reading from a Torah scroll, while another is carrying a Torah scroll and reading from an open book.

In the middle section, the frame on the right illustrates the Rosh Hashanah (New Year's Day) services, with two men dressed in white depicted within a synagogue, where one of the men is blowing a shofar. The scene on the left is a lively portrayal of the *kapparot* (expiation) ceremony, performed on the eve of Yom Kippur, in which the sins of a person are symbolically transferred to a fowl. A man is holding a rooster over the head of a boy and reciting from a prayer book, while a boy and a girl, each holding fowls, are waiting for their turn.

On the right-hand side of the lower section, a man is depicted lighting a large standing Hanukkah lamp inside a synagogue. The middle panel scene represents the reading of the megillah on Purim. A boy is holding a noisemaker, ready to use it whenever there is mention of the name of Haman, the evil character in the Purim story. The scene in the lower left corner gives evidence of the practice of flagellation among German Jews on the eve of Yom Kippur.

I F

Paper, pen and ink, watercolors.
H: 9 in. (23 cm); W: 13 ½ in. (34.5 cm).
The Israel Museum Collection 169/25; HF107.
The Feuchtwanger Collection, purchased and donated
to The Israel Museum by Baruch and Ruth Rappaport of Geneva.

THE FALL OF GOLIATH

Eretz Israel, Early 20th century

Moses Shah (?)

The biblical story of the young David triumphing over the Philistine warrior Goliath in battle in the Valley of Elah (I Samuel 17) has been a popular subject among artists. Despite Goliath's great size and David's relative youth, the young boy managed to kill the giant with a slingshot. This motif must have inspired the Jewish folk artist who executed this glass painting.

Although the painting is not signed, it has been attributed to Moses Shah, who produced similar folk paintings using the same technique. Another smaller, but almost identical version of the same theme, is known to exist in a private collection in Israel. Moses, son of Isaac Shah Mizrahi, was born around 1870 in Teheran, Iran. Before immigrating to Israel around 1890, he seems to have learned the technique of painting on glass by covering the entire surface from the back and then forming the images by scratching or peeling off the paint and gluing on colored foil. In Iran he worked as a scribe (*sofer setem*) of Torah scrolls, phylacteries, and mezuzahs, and after his arrival in Israel opened a shop for picture frames and mirrors in the Old City of Jerusalem. In his shop he created folk paintings, usually painted on glass. In spite of the fragile nature of the material, quite a few of his works survived. These include amuletic *shiviti* (the opening word of the verse from Psalms, "I have set the Lord always before me. . . .") plaques for synagogues, mizrach paintings, and other decorative pictures for the home, representations of the Temple and the holy places, as well as some biblical scenes depicting the story of the Book of Esther, the sacrifice of Isaac, and the fall of Goliath. His paintings, and in particular his depictions of the sacrifice of Isaac, reflect the style of similar scenes found on Iranian carpets. Moses Shah was active in Jerusalem at least until the late 1920s, and he is also known to have produced some lithographs.

In the scene of the fall of Goliath pictured here, the artist focused on the huge decapitated body of Goliath lying horizontally in the middle of the painting. Goliath's head is carried on a sword held by David, who is accompanied by his brothers. Next to David there is a depiction of Goliath's helmet and four Philistine warriors raising their hands in lament over their dead leader. On the right, is a group of uniformed soldiers arranged in rows. On the upper register, King Saul beneath a canopy is watching the scene, flanked by two rows of soldiers. Inscriptions in Hebrew identify the various components of the painting, specifying: "Philistines," "Goliath the Philistine," "the bronze helmet of Goliath," and "David and his brothers." The whole scene is labeled in an arch above "King Saul and Men of Valor and David with Goliath the Philistine."

I F

Oils on glass.
H: 19 ¼ in. (49 cm); W: 23 ½ in. (59.5 cm).
The Israel Museum Collection 177/89; HF120.
The Feuchtwanger Collection, purchased and donated to The Israel Museum by Baruch and Ruth Rappaport of Geneva.
Photograph: Yoram Lehmann.

AMULETIC PAPER-CUT

Turkey, 19th–20th century

David Algranati

This unusual synagogue amulet plaque, featuring Zechariah's messianic vision, is executed in a delicate multilayered paper-cut technique. The plaque represents the traditional art of Sephardi Jewish paper-cutting in Turkey during the Ottoman reign. A long tradition of this art existed among the Turks in the Ottoman Empire and had reached a very high standard of proficiency. Jewish paper-cutting was no doubt influenced in its technique and decorative style by Turkish craftsmanship, while the iconography and subject matter is derived primarily from the Jewish world and its influences.

David Algranati, the artist who created this plaque, also made two other known signed plaques, a *shiviti* and another amulet plaque, both housed in The Israel Museum collection. In all of his works he demonstrates a very sophisticated and delicate type of workmanship, which attests to his skill, and perhaps also to a long tradition of craftsmanship, although no trace of this has been discovered as yet.

The plaque featured here is composed of different colored papers, cut in several multilayered techniques, overlaying and underlaying. The symmetrical layout consists of separate cutouts of one, two, or even more layers stuck on to background paper. The underlaying technique characterizing the work of this artist creates a delicate contour around some of the intricate lattice designs. In the example presented here, this is particularly evident in the olive trees. Illusory effects of spatial depth are created, though not as cohesive as dictated by Western rules of perspective.

This plaque is exceptional in its subject matter. It is a pictorial illustration of the text of Zechariah's eschatological vision of the seven-branched candelabrum (Zechariah 4:1–7). The text itself is inscribed in cut-out letters within the medallions in the frame of the plaque: "I see and behold a lampstead all of gold, with a bowl on top of it and seven lamps on it . . . and there are two olive trees by it, one on the right of the bowl and the other on its left." Also illustrated is verse 12 occurring later in the same chapter but not included in the inscription ". . . the two golden pipes from which the oil is poured out."

The menorah in the center is inscribed with Psalm 67. The initials of the prayer *Anna be-khoah*, creating the forty-two-letter name of God, are inscribed in the two cypress trees flanking the menorah. These two inscriptions are featured very often on amulets and are believed to be endowed with mystical properties.

The plaque bears a striking resemblance in composition and color scheme to the only other known full-page illustration of the same vision of Zechariah, that of the Cervera Bible, written and illustrated in Spain in 1300 by the artist Yoseph ha-Zarphati. This affinity both in form and content may hint at a line of iconographical tradition drawn from Spain before the expulsion of the Jews in 1492 to nineteenth-century Turkey. As there is no other evidence of such a continuity of iconographical tradition, however, this linkage remains hypothetical.

E J

Multilayered paper-cut.
H: 17 ¾ in. (45 cm); W: 16 in. (41 cm).
The Israel Museum Collection 168/58; 616.85.
Photograph: Nahum Slapak.

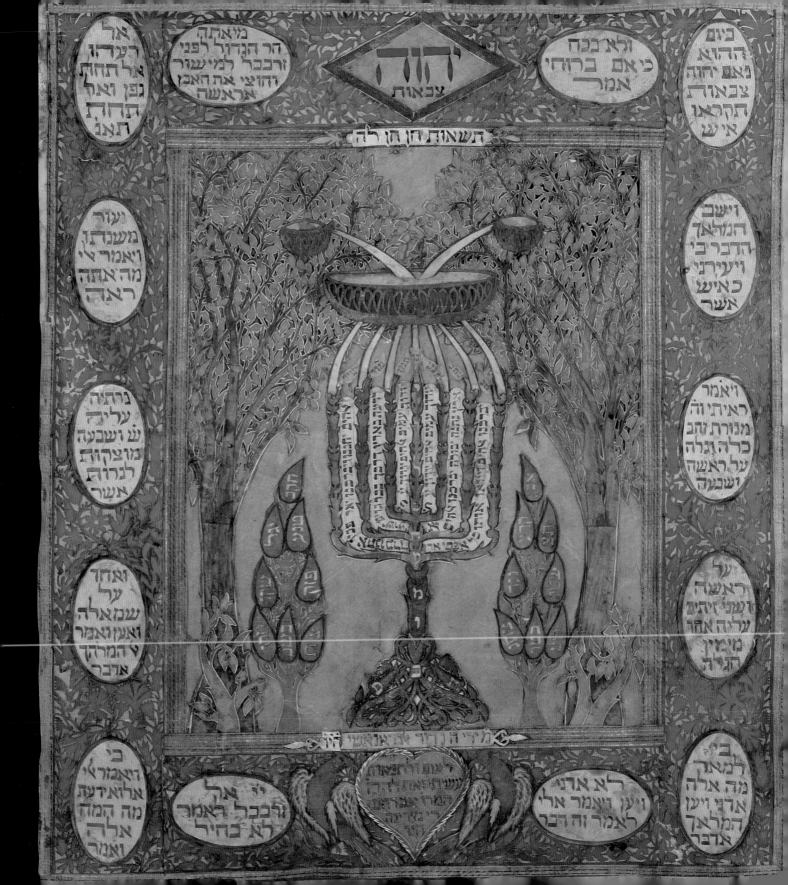

AMULET NECKLACE

Yemen, Early 20th century

This type of necklace, called a *lazem,* was prevalent throughout Yemen with local variations. It was worn by both Jewish and Muslim women in rural areas, but only by Muslim women and very young Jewish girls in the city of San'a, where there existed a strict differentiation in apparel between Muslims and Jews. Silversmiths in Yemen were nearly always Jewish.

The lazem appears with many variations. It usually has one, three, or five plaques (always an odd number), joined by parallel cotton strings adorned with a variety of silver beads. After passing through the end-plaques, the strings are braided in the back into a cord. As with most Yemenite necklaces, the silver part does not continue all the way around the neck, both for economic reasons and also to ensure greater comfort.

The seven strings on this necklace are gathered in the center by a square plaque, and at the two ends by two triangular plaques. The plaques are hollow and decorated on the obverse side with silver granulated rosettes, rhombi, and small flat discs—all typical Yemenite decorative motifs. The plaques' reverse sides are smooth.

Upon the strings are different-shaped silver beads: polygonal and round, as well as cubes constructed of little granules. Assorted coral beads (*mirjan*) of various tones and sizes are interspersed between the silver beads. Corals were very popular both because of their color which was considered a symbol of beauty and youth, and because they were believed to be invested with the power to stem excessive bleeding. In time these beads became rather expensive and were frequently replaced by, or used in combination with, imitation corals.

Seven small charm cases with filigree pendants hang from the lowest row of the necklace and from the central plaque. Designed as hollow tubes, the pendants function as amulet containers, a common feature in the jewelry of the Muslim East. In Yemen, as in most traditional societies, amulets functioned as a means of protection from evil and for the invocation of beneficial forces. Frequently, the amulets contain a magic formula written on paper or parchment. Jews liked to insert a portion of the Bible into this type of amulet, which they called *ktab* or the plural *kutub;* and Muslims, who referred to it as *ḥirz,* a passage from the Koran. In our necklace, however, as in many others, the receptacles' ends are soldered closed, which indicates that the tubes are empty. In this case, the receptacles themselves fulfilled the amuletic function.

Seven coins—a Maria Theresa taler and Indian rupees—and two filigree disks are also attached to the lowest row of the necklace, further adding to its wealth.

In Israel, necklaces of this type are still found among the cherished possessions of women who came from rural areas in Yemen. They are seldom worn, however; their bulk and weight make them ill-suited for modern life.

E M - S

Silver, filigree; granulation; corals; coins.
L: 18 in. (45 cm); W: 13 ⅓ in. (34 cm).
The Israel Museum Collection 333.67.
Photograph: David Harris.

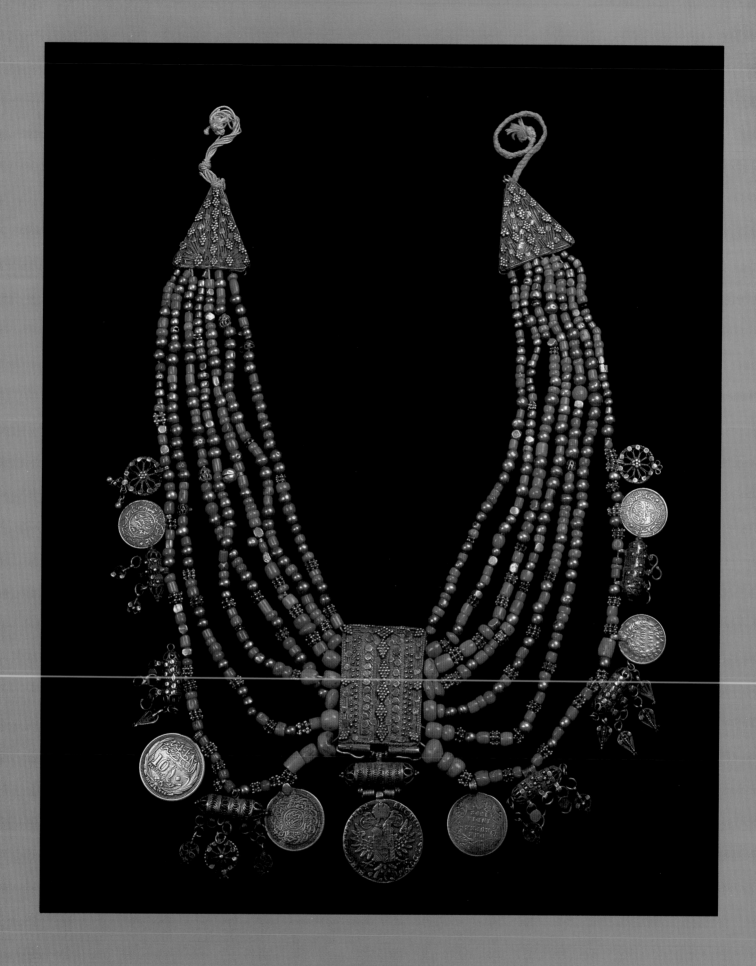

MARRIAGE CONTRACT

Holland, 1648

Shalom Italia

The *ketubbah* is a contract of marriage between a Jewish man and wife. In this contract, recorded in the presence of two witnesses, the groom undertakes to guarantee the wife's sustenance should the marriage be dissolved. Among Sephardi Jews, the standard text is often complemented by additional conditions (*tena'im*) listed on the same document. In the ketubbah reproduced here, the special conditions were written within the cartouche designated especially for that purpose at the bottom of the contract.

The groom, Isaac Pereira, son of Abraham Pereira, and the bride, Rachel, daughter of Abraham de Pinto, were members of two noted Sephardi families of Holland. The custom of illuminating the ketubbah was particularly popular throughout the Sephardi diaspora, and it must have originated in Spain before the expulsion in 1492. While the text of this contract is handwritten, its border decoration was copper-etched and printed on the parchment.

This ketubbah is the work of the well-known Jewish artist Shalom Italia (c. 1619–c. 1655), who was apparently born in Mantua, Italy, and was active in Holland, where he produced decorated Esther scrolls, book illustrations, portraits, and decorated ketubbah forms. Of the specific form shown here, which was signed at the bottom by Shalom Italia in Hebrew, only two copies have survived; the one from The Israel Museum Collection and another, recording a marriage that took place in Amsterdam in 1654. A different, less intricate ketubbah by Shalom Italia was recently discovered. Its text was written in Amsterdam in 1648, and its decoration, featuring urns with flowers along the sides and allegorical figures on top, appears to be the prototype for a common type of printed ketubbah frame that was used by Sephardi Jews in Holland and Germany.

The decoration of The Israel Museum ketubbah includes six vignettes depicting biblical couples, starting with Adam and Eve at the top right and culminating at top left with a portrayal of the newly married couple, shown wearing contemporary attire of wealthy seventeenth-century Dutch Jews. The marriage scene is inscribed with a biblical verse: "Sanctify yourselves therefore, and be ye holy. . . ." (Leviticus 20:7). The other scenes, depicting episodes from the lives of biblical couples, are also all inscribed with appropriate quotations from the Bible. They represent clockwise from the top right: Adam and Eve in the garden of Eden, inscribed "she shall be called Woman" (Genesis 2:23); Abraham and Sarah on their way to Canaan, "And Abram took Sarai his wife" (Genesis 12:5); Jacob kissing Rachel at their first meeting, "And Jacob kissed Rachel" (Genesis 29:11); Ruth and Boaz at their marriage, "And let thy house be like the house of Pharez" (Ruth 4:12); and Rebekah with Eliezer, Abraham's servant, on his errand to find a wife for Isaac, with the inscription: "The thing proceedeth from the Lord. . . ." (Genesis 24:50).

I F

Parchment, hand-colored etching and engraving, pen and ink.
H: 14 ¾ in. (37.5 cm); W: 13 ¼ in. (33.7 cm).
The Israel Museum Collection 179/6; 257-4-51.
Gift of M. H. Gans, Amsterdam.
Photograph: Nahum Slapak.

BRIDAL CASKET

Northern Italy, Second half of the 15th century

This rare bridal casket called a *cofanetto* appears to have been a gift presented to a Jewish bride by her bridegroom. On the front are illustrations portraying the three duties specifically incumbent upon Jewish women. From right to left these tasks are: *ḥallah,* setting aside a portion of the dough; *niddah,* ritual immersion at the end of the menstrual cycle; and *hadlakat ha'ner,* kindling of the Sabbath lights. These commandments are commonly known by their mnemonic abbreviation HANAH. Each is represented by a depiction of a woman performing the task, along with scrolls inscribed with the blessings said on the specific occasions. According to the Talmud: "For three sins women die in childbirth: because they are not observant of *niddah, ḥallah,* and the kindling of the [Sabbath] lights" (Babylonian Talmud, Shabbath 31b).

The function of the small casket is somewhat enigmatic. On its lid are eight dials arranged in two rows. Each dial has a single hand and is surrounded by Hebrew letters that are the numeric equivalent of one to twelve (sometimes only to ten or eleven). The inscriptions next to the dials are written with Hebrew letters, but the words themselves are Italian and seem to indicate a list of the household linens. The list includes a variety of linens, including sheets, tablecloths, towels, men's shirts, women's shirts, and aprons. The hands on the dials of the casket could be turned to indicate the number of each item which the household possessed and thus used to keep an inventory of the holdings. In this manner the non-Jewish servants, not being able to read the Hebrew characters, were supervised and prevented from stealing the linens.

In his study of the object, Mordechai Narkiss suggested that this casket was actually used to hold the keys to all the woman's linen caskets, and that on the Sabbath she would wear the one key to this casket as a pin to avoid carrying it. As early as the beginning of the thirteenth century, in his book *Sefer ha-Terumah,* Baruch ben Isaac of Worms discusses the jewelry that a woman may wear on the Sabbath and mentions a silver key attached to a pin. It seems that wealthy women put all the keys to their linen caskets in one small casket and had the key to this small casket made of silver or gold, which they fastened with a pin to their garment on the Sabbath.

An obliterated name, which can probably be read as Yeshuron Tovar, is inscribed on the lid. It has been suggested that this is the name of the artist who made the casket. It has also been pointed out that the Italian dialect of the inscriptions indicates the Veneto region as a possible place of origin for this unique piece of Jewish art of the Renaissance period.

I F

Silver, cast; engraved, niello; partly gilt.
H: 2 9/16 in. (6.6 cm); L: 5 in. (13 cm); W: 2 3/8 in. (6 cm).
The Israel Museum Collection 131/30; 207-4-51.
Gift of Astorre Mayer, Milan.
Photograph: Yoram Lehmann.

BURIAL SOCIETY GLASS

Bohemia, 1713

The Israel Museum burial society glass is one of a few extant Jewish Bohemian glasses of its kind. These glasses were used by the burial societies (*Hevrah Kaddisha,* literally "Holy Society" in Aramaic), at their annual banquets which were often held on the 7th of Adar, the traditional anniversary of the death of Moses (whose burial place is unknown). During these festive banquets, officials of the society were elected for the next term, and other affairs of the organization were formally attended to. Wine was poured into the glass, and after the blessing was recited, it was either passed around for all to partake, or the wine was then poured into individual cups.

The burial society cups are reminiscent of Christian guild goblets of Germany and Bohemia. The glass vessels clearly reflect the artistic tradition of painting glass, whose standards were quite high in Bohemia. As it was customary to decorate the vessels with depictions of the activities performed by the members of the guilds or societies, the burial society vessels feature a representation of a funeral procession depicted in detail, often accompanied by various biblical and talmudic inscriptions.

This burial society glass from Prague is effectively sectioned off into three distinct segments. An inscription constitutes the upper section, a depiction of a funeral procession forms the middle segment, and an oval medallion is set in the otherwise empty lower section.

The funeral procession on the middle section of the glass shows the deceased carried on a stretcher with his pale face exposed, or perhaps his face is covered by a thin veil. The male mourners include two boys wiping tears from their eyes, and one boy reciting the memorial prayer, *Kaddish,* the first word of the prayer being emitted from his mouth. They are followed in the procession by a group of female mourners. The widow is given a knife by another woman

for the traditional *qeri'ah,* rending of her garment. Among the men, a man is also depicted extending a knife to one of the mourners for the rending of the garment. At the head of the procession another secondary scene shows a man putting a coin into an alms box held by another. The man holding the box is uttering the inscribed words "Righteousness delivereth from death" (Proverbs 10:2; 11:4). A woman holding another alms box is walking at the end of the procession.

Within the oval medallion on the lower band is a miniature depiction of the mourner's meal accompanied by an appropriate inscription (Ecclesiastes 7:2). It shows a man seated at a table on which is placed bread, an egg, and wine. A walled cemetery is depicted in the far background.

The inscription on the upper part of the glass consists of biblical and talmudic phrases concerning death and mourning, drinking of wine and preaching. It indicates the date and the name and titles of Rabbi Baruch Segal Austerlitz of Kolin. It is not clear from the inscription whether this rabbi was the donor of the vessel, or whether the glass was made in his honor.

I F

Glass, enamel paint.
H: 9 5/8 in. (24.5 cm); Diam: 6 3/16 in. (15.7 cm).
The Israel Museum Collection 133/113; 152-1-51.
Photograph: Yoram Lehmann.

לנצח חש... ...ילא אקף ...וטרין ...גם ארוך מריםמות לנצח במו שנאמרחבל מוהרר ברוך סגל · ...דור מדק קעלן ישמרם ·

ושיחאזו את הבגדים שומרה בקרו

מלכת אל בית המושת

BREASTPIECES

Morocco, 19th–20th century

The breastpiece, or plastron, was an important part of the ceremonial and wedding dress of urban Jewish women in Morocco. The extravagant wedding costume called "the Great Dress," was fashioned according to a tradition brought to Morocco in the fifteenth century by the Jews expelled from Spain, who chose to settle in the major cities of their new country.

The dresses were composed of a number of separate pieces, including a skirt, vest, and plastron. The plastron was worn underneath the vest, covering the chest. Of all the pieces which make up this dress, the plastron is the most profusely decorated, most of the surface being covered with gold thread embroidery in floral designs, sometimes with bird motifs as well.

This intricate costume is different from the Muslim wedding gown, which consists of a straight-cut dress. The Jewish costume varies regionally according to the color of the velvet, as well as according to the ornamentation. In the northern regions the dress is made of purple, black, or navy blue velvet; in the central regions the velvet is green; and in the cities on the coast the color is dark red.

Two of the plastrons presented are from the northern city of Tetouan. The first plastron (upper right), probably from the early nineteenth century, is the only remnant of a Great Dress of that period. Its embroidered ornamentation is composed of three distinct sections covering most of the surface. The delicate gold thread embroidery creates a geometric pattern with stylized floral designs on the lower part.

The second plastron from Tetouan (lower right) is either from the end of the nineteenth or beginning of the twentieth century and is part of the oldest dress preserved in the museum's collection. Unlike the first example, this plastron is composed of one strip of material, the decoration divided by the composition: a top strip, middle panel, and a distinct border design. The stylistic floral pattern is imbricated with a flower design in the shape of a Hamsa (Arabic for five) hand, a popular protective amuletic motif.

The third plastron (lower left) is from the city of Rabat. Its dark red- colored velvet is decorated with gold thread embroidery couched on leather cutouts. The floral patterns are organized around a central motif of tendrils encircling a kind of palmette.

The fourth plastron (upper left), from the Fez-Sefrou region, differs from the previous items in both style and technique. It is made of green velvet with gold and silver cord embroidery. The decoration features a scroll pattern around the neckline, here in a free and airy composition.

As the Great Dress was brought to Morocco by Jews originating in Spain, so too was the art of producing gold thread for embroidery and weaving. This industry was centered in the larger cities, particularly in Fez. Gold for the thread was melted down from jewelry and coins, as well as from gold bars imported from Europe. The handmade production of these precious gold threads effectively ended around the 1930s with the mechanization of the process.

Gold thread production and embroidery were Jewish professions, in which both men and women participated. Travellers to Tetouan in the eighteenth century described the skill of the Jewish embroiderers and praised the embroidery of the Great Dress. Torah mantles, Torah ark curtains, and decorative wall hangings were also embellished with gold thread embroidery.

A B - A

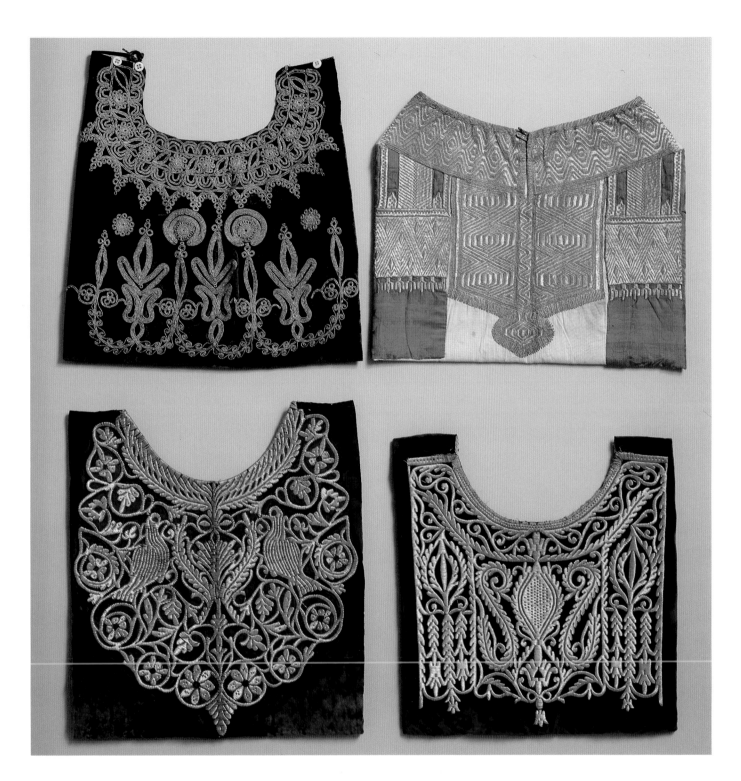

Upper left:
Fez-Sefrou, early 20th century.
Velvet, metal thread cord embroidery.
15 ¾ × 19 in. (40 × 49 cm).
The Israel Museum Collection 1551.12.66.

Lower left:
Rabat, early 20th century.
Velvet, gold thread couched embroidery on cutouts.
18 ⅛ × 18 ⅞ in. (46 × 48 cm).
The Israel Museum Collection 729.72.
Gift of Baroness Alix de Rothschild,
Les amis du Musee d'Israel, Paris.

Upper right:
Tetouan, early 19th century.
Silk, cotton, gold thread couched embroidery.
12 ½ × 16 in. (32 × 41 cm).
The Israel Museum Collection O.S. 3265.66.

Lower right:
Tetouan, late 19th century.
Velvet, gold thread couched embroidery on cutouts.
15 × 17 in. (38 × 43 cm).
The Israel Museum Collection 1403.8.66.
Gift of Raphi Moskuna, Jerusalem
Photograph: Yoram Lehmann.

WOVEN WOOL CARPET

Kurdistan, 20th century

Jews have lived in Kurdistan, according to their own traditions, since the dispersion of the Ten Tribes. The country is mountainous, and heavy snowfalls occur in the northern and central districts during the winter months. Agriculture and herding are the chief occupations. Both Muslims and Jews owned plots of land, cultivated orchards, and kept flocks of sheep and goats. These flocks provided meat, milk and milk products, as well as goat hair and sheep's wool from which cloth, blankets, and carpets were woven. Weaving was an important occupation, although interestingly, it seems not to have been widely practiced by the Muslims. Apparently, Muslims engaged only in the most basic techniques of weaving, such as kelim and knotting. Among Jewish men, on the other hand, weaving was one of the characteristic occupations, along with goldsmithing and merchantry.

Nineteenth- and twentieth-century Jewish travellers' descriptions often refer to weaving as a Jewish occupation, and immigrants from Kurdistan in Israel support this contention. Some folk tales and travellers descriptions describe the art of weaving as a Jewish vocation. While Jewish men were experts in complex weaving, producing rugs and hangings on a horizontal treadle loom fixed to the ground, Jewish women employed the kilim and knotting techniques for weaves of domestic use.

There is no information on the origins and development of weaving in Kurdistan. It has been reported that certain families had been weavers for generations. Weavers tended to specialize, working only on hangings or cloth for men's garments. Some weavers worked only part of the year, during the dead agricultural season. The art began to be learned at around the age of eight, and after about seven years of training the weaver was considered capable of independent production.

The Kurdish home had no furniture in the occidental sense, so rugs and hangings performed many useful, as well as decorative, functions. Carpets were laid out over most of the floor space, and mattresses covered with woven pieces of material were arranged along the walls. There were cradle covers, winter blankets which were sewn together to form a sack, and summer blankets which were fine and almost transparent. Fine hangings were specifically made and used by Jews for a variety of purposes both religious and secular: for the wedding chamber, hangings were used to section off a part of the room occupied by the whole family to create a space for the young couple during the first week of marriage; they were used as sukkah decorations; as coverings for the festive table (on the floor) on the eve of Passover; and as a cover for the deceased. Woven hangings were an important part of a person's life, accompanying them from birth to death.

The finer types of hangings possess many common elements, but certain components of technique, color, and pattern can be regionally differentiated.

The carpet pictured here is from the central region and incorporates images such as a stork, airplane, lighthouse, and flag, which were apparently woven in anticipation of the pending immigration to Israel.

OS-B

6 9/16 × 7 7/8 ft (200 × 240 cm).
The Israel Museum Collection 198.80.
Photograph: Nahum Slapak.

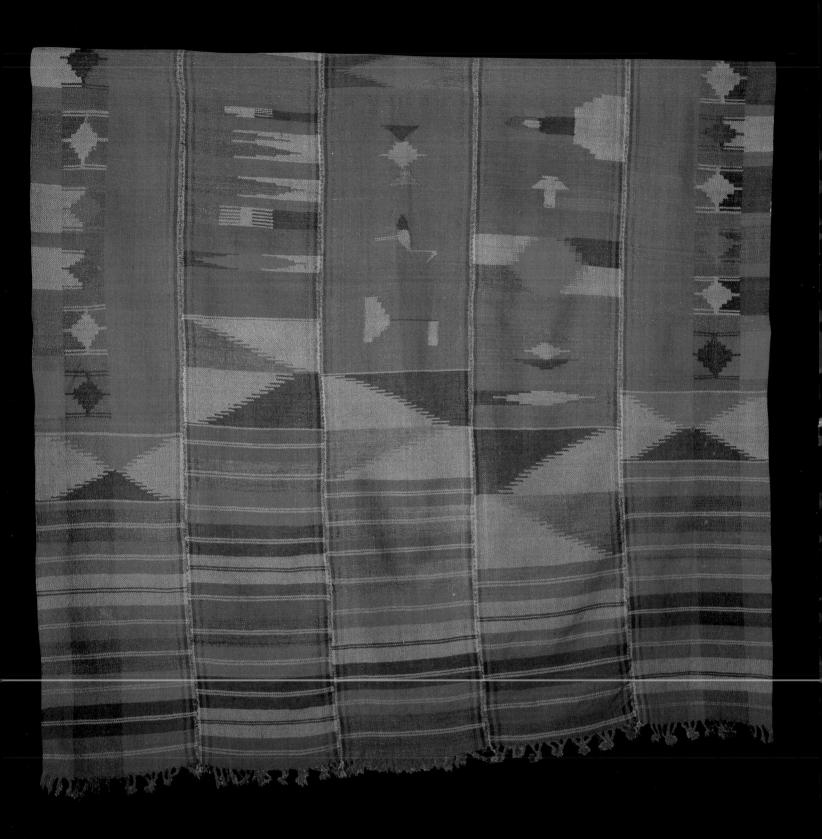

CIRCUMCISION SET

Bohemia, 1681

The commandment of the circumcision is one of the foundations of the Jewish religion, recalling God's covenant with Abraham. "This is my covenant, which ye shall keep, between me and you and thy seed after thee; Every man child among you shall be circumcised. And ye shall circumcise the flesh of your foreskin; and it shall be a token of the covenant betwixt me and you. And he that is eight days old shall be circumcised among you, every man child in your generations" (Genesis 17:10–12).

The circumcision rite is performed on male babies when they are eight days old by a qualified circumciser (*mohel*), using special implements. During the ceremony the infant is held in the arms of his godfather (*sandak*), who sits on a special "chair of Elijah." The mohel set and its accessories are kept in fitted cases. The sets include a special knife, flask for disinfectant powder, clamps, bowl for the foreskin, cups and double beaker (for the extraction of a drop of blood and for the blessing), appurtenances, and scissors. In addition, the mohel kept the "circumcision book," specifying rules and procedures of the circumcision. At the back of this book he would often list the circumcisions carried out. Among these books are manuscripts illustrating the circumcision ceremony.

The valuable flask and knife featured here, with the Hebrew inscription engraved on gold plaques, attest to the importance of the ceremony and the honor granted to the mohel performing it. Along the two sides of the knife's handle is engraved "I rejoice over your promise as one who obtains great spoil" (Psalms 119:162) and "To glorify the commandment of the Lord with precious silver and gold." On the flask is inscribed "B[elongs] to me Noah Catvan son of the late Isaac of Prague; The Year of [5]441 [= 1680–1]." On the reverse side is inscribed "Keep my commandments and be pure and as one with them." The numerical equivalent of the letters of this last inscription indicates the same Hebrew year. The perfect form of the letters points to a connection with the illustrious art of printing and design of Hebrew letters, prevalent in the city of Prague.

This set bears witness to the era of wealth and development which the Jews of Prague experienced during the seventeenth century.

The two objects pictured here are designed in a late Renaissance style with silver-leaved mounting strips, moldings, scroll cast handles, knop finials, and blade decorations. Minute perforations, delicate engraving, and degraded file work, together with the severe shapes and details, create its quality and finesse. It is more common to find silver-mounted glass, ivory, or shell, rather then a gold flask mounted with silver as is depicted here.

It seems safe to assume that the goldsmith who created these items was a Jew: this is because of the dominance of the Hebrew letters in the design, their size and perfection, and due to the fact that there were organized Jewish guilds in Prague in the seventeenth century.

C B

Gold, repoussé and engraved;
silver engraved, chased, pierced, and cast; steel.
Flask: H: 5 in. (12.7 cm); W: ⅞ in. (4.7 cm).
Knife: L: 6 ¾ in. (17.5 cm); W: ½ in. (2.3 cm).
The Israel Museum Collection 112/149; 228.86, 112/150; 229.86.
The Stieglitz Collection was donated to The Israel Museum with the contribution of Erica and Ludwig Jesselson, New York, through the American Friends of The Israel Museum.
Photograph: Avi Ganor.

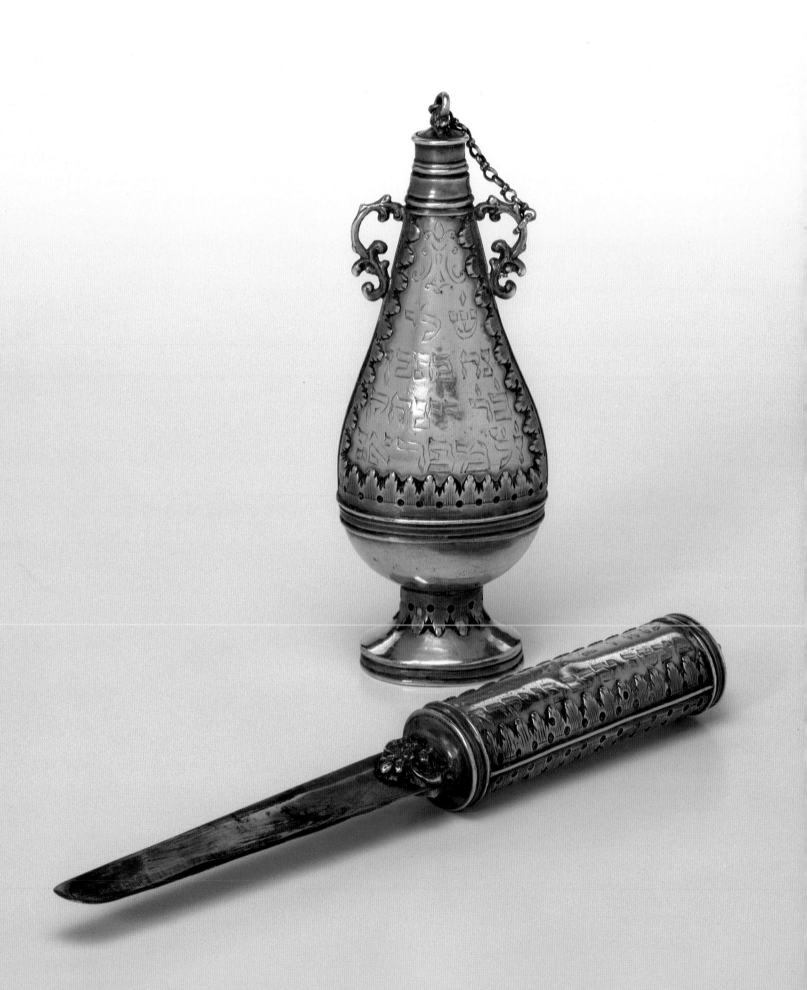

THE WEDDING

Germany, 1861

Moritz Oppenheim

Moritz Oppenheim (1800–1882) was rightly called the first Jewish painter. When he was in his fifties, Oppenheim began work on a series of Jewish genre paintings: *Bilder aus der altjüdische Familienleben* (Pictures of Traditional Jewish Family Life). A complete edition of twenty paintings was first published in Frankfurt am Main in 1882 with an introduction and commentary by Rabbi Dr. Leopold Stein. The *Bilder* series aroused much interest throughout the Jewish world and was published in a variety of formats and editions. In his sixties, Oppenheim was asked to repaint the works in the grisaille technique (painting in gray tones) in order to facilitate their photographic reproduction.

The figures in the series wear late rococo-style clothing and are placed in the preemancipation Frankfurt ghetto. By choosing this archaic mode, the artist could show the love and faith which imbued the way of life in bygone days, and could thus preach for their continuance and fight the trend towards assimilation. He describes the various Jewish traditions and rituals with great accuracy, as can be seen in his portrayal of the Jewish wedding pictured here.

The color version of *The Wedding,* which is in The Israel Museum, was executed in 1861 and differs somewhat from its grisaille replica of 1866 in its iconography. The museum's painting is a tiny canvas, brightly colored and rather crowded. Through a large archway we look into the courtyard of the Frankfurt Synagogue where the ceremony is taking place in the open, according to an old German tradition. Bride and bridegroom, placed in the exact center of the composition, are covered by a *tallith* (man's prayer shawl), symbolizing their unity and residence under a common roof. Both wear long-chained golden belts. These, as well as the tallith, were *sivlonot*—presents exchanged between bride and bridegroom prior to the wedding.

The groom is about to put the ring on the bride's finger. Her excitement is evident from her downcast eyes and whiteness of complexion. The rabbi, whose garb reflects that of an Eastern European Jew, is reading from a scroll, either the blessings or the marriage contract. A very lovely and lively young girl looks up to the man on the right, who is studying the blessings which he will soon be asked to recite. The girl looks as if she wonders how well he will fare with the unfamiliar Hebrew text.

On the opposite wall, we can see a stone with a red Star of David. This is the *Traustein* against which, according to Frankfurt tradition, the bridegroom will smash the ritual glass. This custom derives from the belief that the noise and broken glass will ward off the evil spirits waiting to harm the young and happy couple. Later on, the more common explanation of this tradition was given as the *zekher lahurban,* a reminder of the destruction of the Temple.

The fiddler and the *badhan* (jester), who is watching from the steps leading to the women's gallery, await their turn to lead the festive procession and entertain the company during the wedding meal.

R W - B

Oil on canvas.
14 ½ × 10 ¹³/16 in. (37 × 27.5 cm).
The Israel Museum Collection M 1149/3/56.
Photograph: Nahum Slapak.

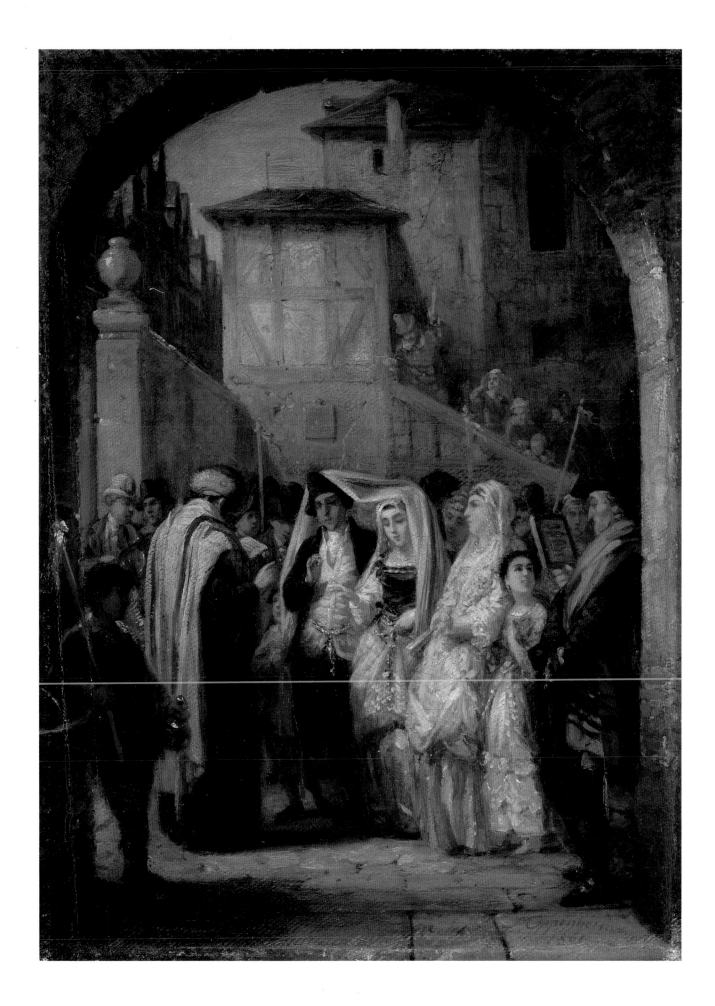

ILLUSTRATION FOR "BOAT TICKET"

Berlin, 1922

El Lissitzky

El Lissitzky (1890–1941), best known as one of the leading Russian avant-garde artists, came to maturity towards the end of the Czarist era. With the outbreak of the Russian Revolution, the Jews were finally granted much-craved freedom, which in turn resulted in a Jewish cultural renaissance. This freedom was also expressed in art, and Lissitzky appeared as one of the leading figures in the field.

However, Lissitzky soon found the Jewish world too confining, and in early 1919 opted for an abstract, universal art form. In doing so, he also wished to serve the cause of the Bolshevik Revolution, of which by now he and most of the Russian avant-garde artists were fervent supporters.

In 1921 Lissitzky temporarily left Russia, arriving in Berlin in 1922. Although his main output during this period consisted of nonrepresentational Constructivist works, among other things he also illustrated a few Yiddish books and produced an illustration for each of Ilya Ehrenburg's short stories in *Six Stories with Easy Endings*. The work featured here illustrates one of the stories in this publication entitled *"Shifs Karta"* (Boat Ticket). Also known as "A Journey to America," it was probably conceived around April 20, 1922, as one of the other six illustrations in the book carries a clip from a newspaper bearing this date.

The importance of this work reaches far beyond that of a simple drawing for a book illustration. Its renown rests on the combination of dramatic visual quality, enigmatic content, and usage of Jewish symbols.

The eye immediately catches the imprint of the black forbidding hand on which the Hebrew letters of *pei* and *nun*, which are an acronym for "here lies buried," have been pasted on in white. Opening the drama are the strong contrasts between black and white, the "soft" contour of the hand, as opposed to the "sharp" contour of the letters, coupled with the mystery of why the artist has seen fit to include the letters from Jewish tombstones.

Additional elements include a section under the hand, fragments of excerpts from a Hebrew text; two opposing triangles forming a skewed Star of David, tilted in the opposite direction of the hand; and at the top, references to a return boat trip between Hamburg and New York. Here Lissitzky has even introduced some color, causing the collage to look quite different from the final illustration in the book.

This many-layered work defies a single interpretation. It has commonly been suggested that Lissitzky is burying the old Jewish world in favor of the new world of the Revolution; or that he is bidding farewell to Europe and Russia (the Old World), seeing the future in America. However, the collage should also be seen in the context of Ehrenburg's story: the main character, an old man, is waiting for a boat ticket from his son in America, hence the title. The story also contains kabbalistic elements, as well as a description of a pogrom, which may explain the Hebrew letters hinting at burial.

While *"Shifs Karta"* constitutes Lissitzky's strongest Jewish work visually, it is also the last example in which he employs Jewish symbols.

RA-G

Collage and india ink.
17 ⅛ × 9 ½ in. (43.5 × 24.1 cm).
The Israel Museum Collection B89.146.
The Boris and Lisa Aronson Collection at The Israel Museum: purchased through a bequest from Dvora Cohen, Afeka, Israel, 1989.
Photograph: Yoram Lehmann.

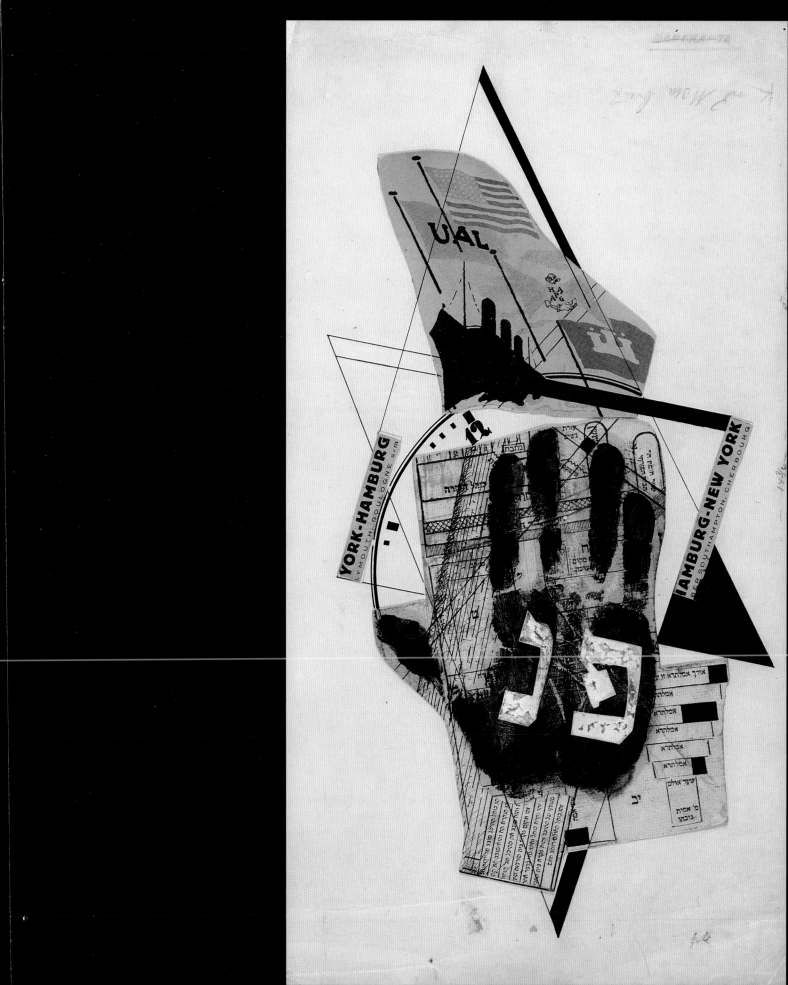

INTERIOR OF A SYNAGOGUE IN SAFED

Eretz Israel, 1931

Marc Chagall

Marc Chagall (1887–1985), the Russian-born artist, noted for his dreamlike paintings, visited Eretz Israel in 1931 for the first time. On that occasion he painted several works in Jerusalem, and three oil paintings of synagogues in Safed. The painting recently acquired by The Israel Museum represents the Ha-Ari Sephardi Synagogue, which today remains virtually unchanged since Chagall documented it more then sixty years ago.

The Ha-Ari Sephardi Synagogue, perhaps the best known of Safed's many houses of prayer, is believed to date back to at least the early sixteenth century. A traveller who visited Safed in 1522 referred to it as the synagogue of the Prophet Elijah. The Ari himself, Isaac Ben Solomon Luria (1534–1572), the venerated sage who established a center for the study of the Kabbalah in Safed, is known to have prayed in this synagogue. Legend has it that after his death, none of his disciples would take his seat; hence, it has remained empty ever since.

Strong sunlight enters through the deepest windows of the old synagogue, permeating the vaulted, whitewashed interior with the bluish midday haze of a warm Mediterranean spring day. The saturated red-brown hues of the ark curtains and the sketchily brushed flower motifs illuminating the rose window above it and the right-hand window lunette invest the space with an air of festivity.

The large central bimah, extending upward in a dramatic thrust that brings to mind the Tower of Babel, forms the focus of the composition. Its lower part is fenced in by closely spaced wooden bars, whereas the upper section opens out like a flower to the sky, giving it near-mystic dimensions. A bearded man with a hat, perched on the railing of the staircase leading up to the bimah, looks oddly suspended in mid-air, recalling the gallery of hovering figures in Chagall's art. Another figure, draped in a vaguely outlined tallith, rests on the stone bench by the window. The incorporeal aspect of these human images enhances the serenely spiritual atmosphere. It is even tempting to see in the ethereal light pervading the small synagogue an intimation of light as contemplated in the Kabbalah. This would not be implausible, since Safed was a famous kabbalistic center, especially during the sixteenth century.

The Israel Museum painting of the Ha-Ari Sephardi Synagogue, while conveying the artist's whimsical yet reverent rendering of Jewish life and tradition, also records Chagall's intense first encounter with Eretz Israel. His later works, replete with Jewish symbolism, are far removed in spirit from the paintings Chagall composed in Safed. Wrought by the traumatic events of the Holocaust, Chagall would indeed never recover the childlike, dreamy mood that had filled him in the old Safed synagogue.

M W

Oil on canvas.
28 ¾ × 36 ¼ in. (73 × 92 cm).
The Israel Museum Collection B91.500.
Purchase made possible by Janine Bernheim and Antoine Wertheimer, in memory of their parents, Madeleine and Paul Wertheimer; and by the Crown Family, Edith Haas, Averell Harriman, Loula Lasker, Edward D. Mitchell, David Rockefeller, and Charles Ullman.
© ADAGP, Paris 1994.
Photograph: Nahum Slapak.

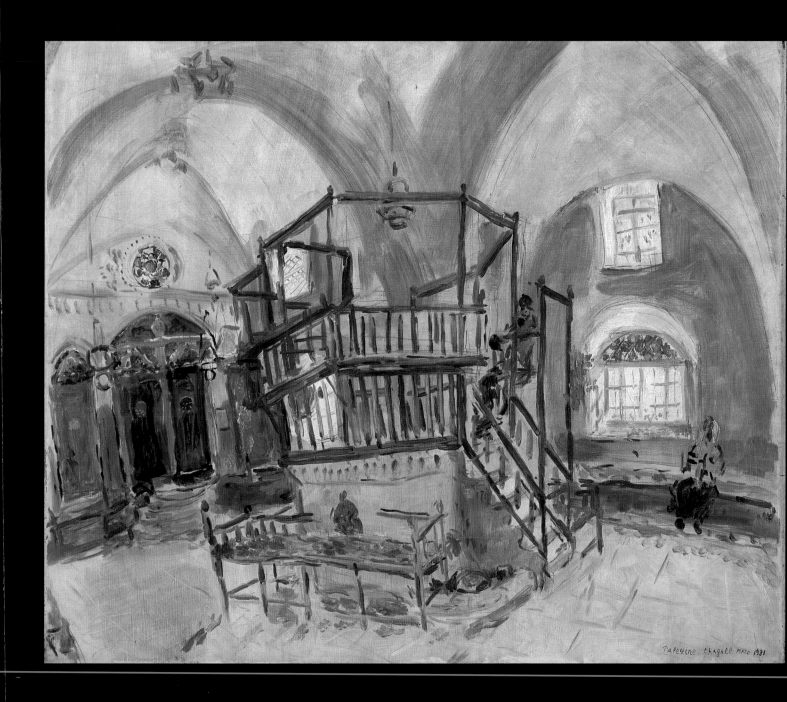
Palestine. Chagall Mars 1931

THE SACRIFICE OF ISAAC

Israel, 1984

Menashe Kadishman

The painter and sculptor Menashe Kadishman (1932–), is an Israeli-born former kibbutz member. In his 1984 version of the biblical theme of the sacrifice of Isaac three figures are depicted: Abraham and Sarah portrayed on the right, and Isaac in the middle. The mountain of Moriah separates the parents from their son, while a donkey enters the scene from the left. In the right corner a vase of flowers stands on a rectangular shape that resembles a sacrificial altar.

The style of the painting is true to the artist's style and colorful palette during the early eighties. What seems to be missing from the composition is his favorite image during those years, the lamb. It seems that the very absence of a lamb is the key to deciphering the enigmatic version of this biblical event.

Kadishman treated this familiar theme dramatically different, in many ways, from the traditional depictions of the scene in European and Israeli art. The artist deliberately ignores the biblical "happy ending," in which the ram is sacrificed instead of the boy. Instead, he chooses to show Isaac clad in black, with a skeletal face, already dead and buried inside the burial mound that takes the place of the holy mountain. Another deviation from the usual iconographic tradition of this scene is the appearance of Sarah at Abraham's side. According to the Genesis story, Sarah stayed behind when her husband took their son on the ominous journey. By adding Sarah into the composition, Kadishman emphasized the horrible difference of his version of the story: Isaac's death. Kadishman was unaware of a rabbinic interpretation suggesting Sarah's witness of the scene of the sacrifice.

Why did Kadishman choose this macabre interpretation?

For many Israelis 1984 was a traumatic year. Many young soldiers were killed on Israel's northern front, sacrifices of the military campaign in Lebanon which had begun two years earlier. People of Kadishman's generation felt that parents were sending the children to Lebanon like sacrificial lambs, while they were staying safely behind, protected from danger by their age.

In more than one version of the sacrifice theme, as well as in many sketches and drawings, the artist repeated the scene with Isaac as a dead, sometimes burned, image. The rectangular shape could thus be seen as a coffin, and the flowers a wreath for the dead. Although the donkey is mentioned in the biblical text (Genesis 22:3–5), here it appears to be an eschatological symbol, suggesting the possible coming of the Messiah and with it the resurrection of the dead, thus bestowing a little hope in this otherwise morbid painting.

S S

Acrylic on canvas.
81 ½ × 76 in. (207 × 193 cm).
The Israel Museum Collection 638.85.
Gift of Ayala Zacks Abramov, Jerusalem.
Photograph: Yoram Lehmann.

STILL LIFE WITH JEWISH OBJECTS

Russia, 1925

Issachar Ryback

Issachar Ryback (1897–1935) was born in Yelizavetgrad in 1897 to a family with a Hasidic background. He studied at the Art Academy in Kiev, the capital of the Ukraine. In the second decade of the twentieth century, the Jewish community in Kiev and other Russian centers flourished artistically in a relatively liberal atmosphere. Ryback's art at this time reflects a synthesis between the Jewish folk art tradition and the contemporary Russian avant-garde streams including Cubism, Constructivism, and Suprematism.

Ryback painted *Still Life with Jewish Objects* in 1925, after his return to the Soviet Union from a four-year stay in Berlin. In this work he uses Cubist division and a Suprematist form in the center of the painting as a modern setting for the presentation of the Sukkot festival.

Ryback portrays three important customs of the holiday. The viewer is invited to stand in front of a table and to participate in the celebration. The first custom of the four species (*arba'ah minim*) of Sukkot is to hold a palm branch (*lulav*), myrtle twigs (*hadasim*), and willow branches (*aravot*) in the right hand and the citron (*etrog*) in the left hand and to wave them while the *Hallel* prayer (Praise to God) is recited. The second custom relates to the open holiday prayer book on the table showing the prayer for rain, recited after the *Hallel*. The third custom is pictured in the yellow Suprematist square in the frame of the window. We perceive a popular print showing Hasidim dancing with the Torah scrolls around the pulpit, as is customary on the ninth day of Sukkot as part of the Simhat Torah festival. It seems as if the excitement of the celebration has caused the first dancer to reach out of the frame of the print and touch the lulav.

The table "falling" toward the right corner of the painting rests on a candlestick. The black box on the left corner of the table reminds us of a candle, while the image of the flame is hinted at in the color and shape of the etrog wrapped with flax. The texture of flax is conveyed by an expressive white impasto, thick layers of paint. Alternately, the black box which protrudes from the two-dimensional surface could be perceived as the box used to preserve the wholeness of the etrog.

While the table seems to be falling down, the lulav forces our eyes to climb up to the arch of the window. Through the arch we can see a view of a remote village. The village is drawn in a naturalistic style, with soft color tones which fade into light gray. A wood plank is placed diagonally across this scene, emphasizing the idea that this personal memory is beyond the reach of the viewer. Ryback completes his praise of the Sukkot festival with a nostalgic memory of a Jewish village. To the right of the arch Ryback paints a white lace tablecloth, an intimate object of the interior of the house.

Ryback went to Paris in 1926, where he began painting in the School of Paris style. He died in Paris in 1935.

E S

Oil and collage on canvas.
37 × 23 ¾ in. (94 × 60 cm).
The Israel Museum Collection B71.183.
Photograph: Yoram Lehmann.

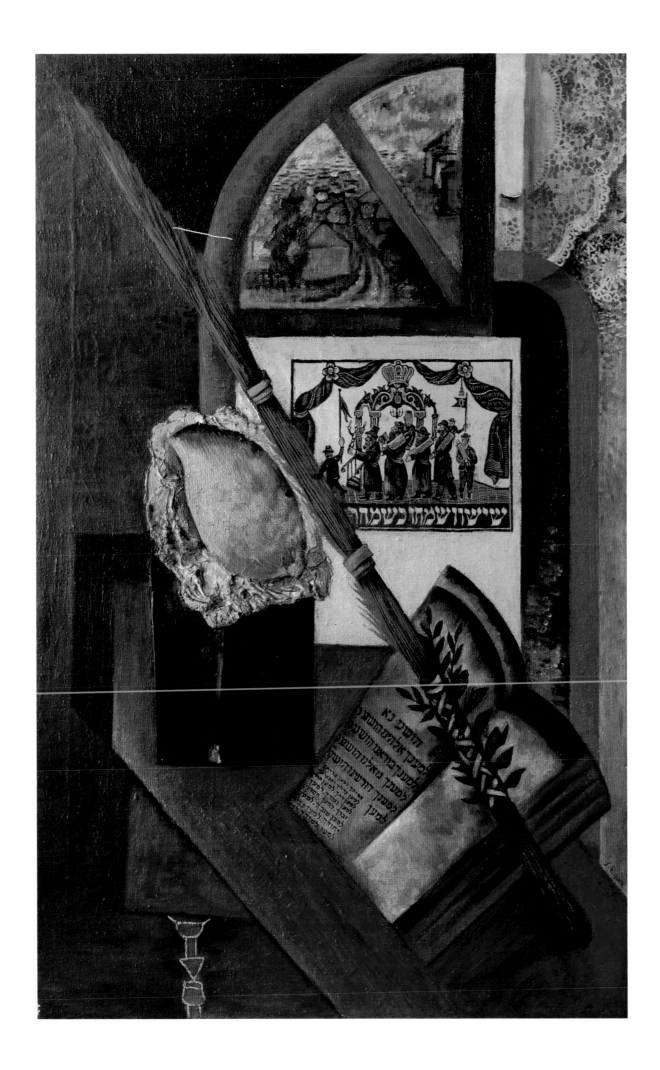

REFERENCES

Ivory Pomegranate, p. 18

H. Shanks, *In the Temple of Solomon and the Tomb of Caiaphas,* Biblical Archaeology Society, Washington, DC, 1993.

N. Avigad, "The Inscribed Pomegranate from the House of the Lord'," *The Israel Museum Journal, 8,* Jerusalem, 1989.

A. Lemaire, "Probable Head of Priestly Scepter from Solomon's Temple Surfaces in Jerusalem," *Biblical Archaeology Review,* January/February 1984.

Coin of Judah, p. 20

Y. Meshorer, *Ancient Jewish Coinage, I,* New York, 1982.

Sarcophagus from a Nazarite Family, p. 22

Treasures of the Holy Land, Ancient Art from the Israel Museum, The Metropolitan Museum of Art, 1986, No. 114.

N. Avigad, "The Burial Vault of a Nazarine Family on Mount Scopus," *Israel Exploration Journal 21,* 1971.

Gold-Glass Base, p. 24

Treasures of the Holy Land, Ancient Art from the Israel Museum, The Metropolitan Museum of Art, 1986, No. 146.

D. Barag, "Glass," *Encyclopaedia Judaica,* Vol. 7, Jerusalem, 1971.

Mosaic Pavement, p. 26

Treasures of the Holy Land, Ancient Art from the Israel Museum, The Metropolitan Museum of Art, 1986, No. 148.

M. J. Chiat, "Synagogues and Churches in Byzantine Beth Shean," *Journal of Jewish Art VII,* 1980.

K. Weitzman, ed., *Age of Spirituality: Late Antique, Early Christian Art, Third to Seventh Century,* The Metropolitan Museum of Art, New York, 1977.

N. Zori, "The Ancient Synagogue of Beth Shean," *Eretz Israel 8,* 1967 (in Hebrew).

Multiple-Nozzle Lamp, p. 28

Treasures of the Holy Land, Ancient Art from the Israel Museum, The Metropolitan Museum of Art, 1986, No. 102.

Highlights of Archaeology, The Israel Museum, Jerusalem, 1984.

Oil Lamp with Menorah, p. 30

Treasures of the Holy Land, Ancient Art from the Israel Museum, The Metropolitan Museum of Art, 1986, No. 26.

Highlights of Archaeology, The Israel Museum, 1984.

The Vittorio Veneto Synagogue, p. 32

U. Nahon, *Holy Arks and Ritual Appurtenances from Italy in Israel,* Tel Aviv, 1970 (Hebrew with Italian and English abstracts).

I. Fishof, "Synagogue Architecture in Italy—Artistic and Historical Aspects", *PE'AMIM—Studies in the Cultural Heritage of Oriental Jewry 8,* Jerusalem, 1981 (Hebrew).

The Horb Synagogue Ceiling, p. 34

H. Poehlmann, "Geschichte und Beschreibung der 'Horber Gebetsstube' in Horb am Main bei Lichtenfels, Oberfranken (Bayern)," *Geschichte des Marktfleckens Küps vom Frankenwalde mit Umgegend,* Lichtenfels, 1908.

D. Davidovicz, *Wandmalerein in alten Synagogen,* Hameln-Hannover, 1969.

J. Motschmann, "250 Jahre Synagoge von Horb am Main— Ein galizischer Künstler gestaltete 1735 eine fränkische Dorfsynagoge," *Vom Main zum Jura, Heft 2,* Lichtenfels, 1985.

Torah Ark Doors, p. 36

M. Balaban, *Historia Zydow w Krakowie i na 1304–1868 Kazimierzu,* 2 vols. (1931–1936).

Torah Finials, p. 38

E. Muchawsky-Schnapper, *The Jews of Yemen: Highlights of the Israel Museum Collection,* The Israel Museum, Jerusalem, 1994.

E. Muchawsky-Schnapper, "Ceremonial Objects in Yemenite Synagogues." In *The Second International Congress of Yemenite Studies,* Princeton, New Jersey (forthcoming).

Torah Ark Curtain, p. 40

F. Landsberger, "Old-Time Torah Curtains," *Beauty in Holiness,* ed., J. Gutmann, New York, 1970.

B. Yaniv, *Sixteenth–Eighteenth Century Bohemian and Moravian* Parochot *with an Architectural Motif,* doctoral thesis, Hebrew University, Jerusalem, 1987.

Torah Ornaments, p. 42

V. B. Mann, ed., *Gardens and Ghettos: The Art of Jewish Life in Italy,* New York, 1989.

Leone Modena, *The History of the Present Jews Throughout the World,* London, 1707.

U. Nahon, *Holy Arks and Ritual Appurtenances from Italy in Israel,* Tel Aviv, 1970 (Hebrew with Italian and English abstracts).

Torah Wrapper, p. 44

U. Nahon, *Holy Arks and Ritual Appurtenances from Italy in Israel,* Tel Aviv, 1970.

Z. Hanegbi, "Conservation of a Torah Mantle in the Restoration Laboratory," *The Israel Museum News, 14,* Jerusalem, 1978.

A. Milano, *Il Ghetto di Roma,* Rome, 1964.

Torah Decorations, p. 46

Z. Hanegbi and B. Yaniv. *Afghanistan: The Synagogue and the Jewish Home,* Jerusalem, 1991.

Torah Shields, p. 48

E. Juhasz, ed., *Sephardi Jews in The Ottoman Empire,* The Israel Museum, Jerusalem, 1990.

From the Secular to the Sacred (exhibition catalog), The Israel Museum, Jerusalem, 1985.

Torah Shield, p. 50

I. Shachar, *Jewish Tradition in Art–The Feuchtwanger Collection of Judaica,* Jerusalem, 1971, 1981.

Y. (R.) Cohen, "Torah Breastplates from Augsburg in the Israel Museum," *The Israel Museum News, 14,* Jerusalem, 1978.

H. Seling, *Die Kunst der Augsburger Goldschmiede 1529–1868,* Vol. III, No. 2104, Munich, 1980.

Torah Ornaments, p. 52

Wolfgang Scheffler, *Goldschmiede Hessens,* Nos. 359, 631, Berlin, 1976.

The Posen Family: The Descendants of Eliezer Lazarus Posen (1803–1865) and his wife Brendina Wetzlar-Posen (1833–1901), London, 1985.

Lazarus Posen Wwe. Hofsilberschmied Frankfurt a M—Berlin W., sale catalogue (exact date unknown).

Cissy Grossman, "Schiff Set of Torah Ornaments," *A Temple Treasury: The Judaica Collection of Congregation Emanu-El of the City of New York,* New York, 1989.

Prayer Stand, p. 54

E. Muchawsky-Schnapper, *The Jews of Yemen: Highlights of the Israel Museum Collection,* Jerusalem, The Israel Museum, 1994.

E. Muchawsky-Schnapper, "A Yemenite 'Tevah' Originally from San'a, Now in Jerusalem," *Jewish Art,* (forthcoming).

Torah Crown with Finials, p. 56

R. Ahroni, *The Jews of Aden: A Community that Was,* Afikim, Tel Aviv, 1991.

Birds' Head Haggadah, p. 58

M. Spitzer, ed., *The Bird's Head Haggada of the Bezalel National Art Museum in Jerusalem, I-II,* (Facsimile and Introduction). Jerusalem, 1967.

B. Narkiss, *Hebrew Illuminated Manuscripts,* Jerusalem, 1969.

B. Narkiss and G. Sed-Raijna, *Index of Jewish Art, I,* Jerusalem-Paris, 1976.

B. Narkiss, "On the Zoocephalic Phenomenon in Medieval Ashkenazi Manuscripts," *Norms and Variations in Art, Essays in Honour of Moshe Barasch,* Jerusalem, 1983.

Sassoon Spanish Haggadah, p. 60

B. Narkiss, *Hebrew Illuminated Manuscripts,* (Jerusalem, 1969, p. 62); Hebrew edition (1984), p. 89.

D. S. Sassoon, *Ohel David—Descriptive Catalogue of the Hebrew and Samaritan Manuscripts in the Sassoon Library,* London, I–II, (Oxford, 1932), 303–4.

I. Fishof, "A Legacy on Parchment: The Sassoon Spanish Haggadah," *The Israel Museum Journal, X,* Jerusalem, 1992.

The Rothschild Miscellany, p. 62

B. Narkiss, *Hebrew Illuminated Manuscripts,* Jerusalem, 1969.

B. Narkiss and G. Sed-Rajna, *Index of Jewish Art, Vol. III (The Rothschild Miscellany),* Jerusalem, 1983.

I. Fishof, ed., *The Rothschild Miscellany,* facsimile edition with commentaries by S. Simonsohn, I. Ta-Shema, M. Beit-Arie, and L. Mortara-Ottolenghi, London, 1989.

Prayer Book of the Rabbi of Ruzhin, p. 64

I. Fishof, "The Origin of the *Siddur* of the Rabbi of Ruzhin," *Jewish Art, 12/13,* Jerusalem, 1986–7.

B. Narkiss, *Hebrew Illuminated Manuscripts from Jerusalem Collections, No. 10;* The Israel Museum, Jerusalem, 1967.

B. Narkiss, *Hebrew Illuminated Manuscripts,* Jerusalem, 1969.

Grace after Meals Manuscript, p. 66

I. Fishof, "Grace After Meals and Other Benedictions." *Introduction to a facsimile edition of Cod. Hebr. XXXII in The Royal Library Copenhagen,* Copenhagen, 1983.

I. Fishof, "Grace After Meals—Seder Birkat Ha-mazon," *Introduction to a facsimile edition of Ms.64.626 in The Jewish Museum of Budapest,* Budapest, 1991.

I. Fishof, "Me'ah Berakhot—One Hundred Blessings." *Introduction to a facsimile edition,* London, 1993.

E. Namenyi, "La miniature juive au XVIIe et au XVIIIe siècle," *Revue des études juives, XVI (CXVI),* 1957.

U. Schubert, *Jüdische Buchkunst,* Graz, 1992.

The Five Scrolls in Micrography, p. 68

E. Namenyi. "La miniature juive au XVIIe et au XVIIIe siècle," *Revue des études juives, XVI (CXVI),* 1957.

U. Schubert, *Jüdische Buchkunst,* Graz, 1992.

L. Avrin, *Hebrew Micrography,* The Israel Museum, Jerusalem, 1981.

C. Sirat, *La lettre hébraïque et sa signification;* L. Avrin, *Micrography as Art,* Paris–Jerusalem, 1981.

A. N. Roth, "The Folk Painter Aaron Schreiber-Herlingen," *Yeda-Am, Vol. V, Nos. 1–2 (21–22),* Autumn, 1958.

Hanging Sabbath Lamps, p. 70

I. Shachar, *The Jewish Year,* Leiden, 1975.

Sabbath Candlesticks, p. 72

In a Single Statement—Works by Zelig Segal, exhibition catalogue, The Israel Museum, Jerusalem, 1992.

Spice Boxes, p. 74

M. Narkiss, "Origins of the Spice Box," *Eretz Israel 6,* 1960 (Hebrew) and in *Journal of Jewish Art 8,* 1981 (English).

Towers of Spice: The Tower-Shape Tradition in Havdalah Spiceboxes, exhibition catalogue, The Israel Museum, Jerusalem, 1982.

Sukkah, p. 76

H. Feuchtwanger, "Sukkah," *Monumenta Judaica, 2000 Jahre Geschichte und Kultur der Juden am Rhein,* Katalog: E 596 and color plates VII and IX, Köln, 1964.

I. Shachar, *The Jewish Year,* Leiden, 1975.

N. Feuchtwanger-Sarig, "Fischach and Jerusalem—The Story of a Painted Sukkah," *Jewish Art, 19–20,* 1993–4.

Hanukkah Lamp, p.78

I. Shachar, *The Jewish Year,* Leiden, 1975.

M. Friedman, "The Metamorphoses of Judith," *Jewish Art, 12–13,* Jerusalem, 1986–87.

Esther Scroll, p. 80

Synagoga (exhibition catalog), B55, Recklinghausen, 1960–1961.

Monumenta Judaica (exhibition catalog), E675, Cologne, 1963–1964.

Lusterware Passover Plate, p. 82

C. Roth, "Majolica Passover Plates of the XVI-XVIII Centuries," *Eretz-Israel 7,* Jerusalem, 1964.

K. Katz, "Jewish Tradition in Art," *From the Beginning,* Jerusalem and London, 1968.

D. Davidovich, "Ceramic Seder Plates from Non-Jewish Workshops," *Journal of Jewish Art 2,* Jerusalem, 1975.

L. Avrin, "The Spanish Passover Plate in the Israel Museum," *Sefarad 39,* Madrid, 1979.

Mizrach, p. 84

I. Shachar, *Jewish Tradition in Art—The Feuchtwanger Collection of Judaica,* Jerusalem, 1971, 1981.

The Fall Of Goliath, p. 86

H. Feuchtwanger, "Moshe Shah, the Jerusalem votiv-painter," *Yeda-'Am 1-2 (vol. IV),* 1956.

I. Shachar, *Jewish Tradition in Art–The Feuchtwanger Collection of Judaica,* The Israel Museum, Jerusalem, 1971, 1981.

Y. Fisher, ed., *Art and Craft in Eretz-Israel in the 19th century,* The Israel Museum, Jerusalem, 1979 (Hebrew).

Amuletic Paper-Cut, p. 88

E. Juhasz, "Paper-Cuts," in *Sephardi Jews in the Ottoman Empire: Aspects of Material Culture,* E. Juhasz, ed., The Israel Museum, Jerusalem, 1990.

B. Narkiss, *Hebrew Illuminated Manuscripts,* p. 79, pl. 6, Jerusalem, 1984.

Amulet Necklace, p. 90

E. Muchawsky-Schnapper, *The Jews of Yemen: Highlights of the Israel Museum Collection,* The Israel Museum, Jerusalem, 1994.

E. Muchawsky-Schnapper, "Iconography and Interpretation in Yemenite Jewellery," in *Jewellery and Goldsmithing in the Islamic World,* N. Brosh, ed., The Israel Museum, Jerusalem, 1991.

Marriage Contract, p. 92

M. Narkiss, "The Oeuvre of the Jewish Engraver Shalom Italia," *Tarbiz 25* (1956), and 26 (1957) (Hebrew, English summary).

S. Sabar, "The golden age of ketubah decoration in Venice and Amsterdam," *The ghetto in Venice,* Julie-Marthe Cohen ed., Jewish Historical Museum, Amsterdam, 1990.

S. Sabar, *Mazal Tov–Illuminated Jewish Marriage Contracts from the Israel Museum Collection,* Jerusalem, 1993.

Bridal Casket, p. 94

M. Narkiss, "Cofanetto italiano d'argento niellato del sec XV," *Scritti in Memoria di Sally Meyer,* Milano, 1956 (also appeared in Hebrew). Reprinted in English "An Italian Niello Casket of the Fifteenth Century," *Journal of the Warburg and Courtauld Institute,* XXI (1958). Reprinted in Hebrew "The Secret of an Italian Casket from the Fifteenth Century," *Rimmonim, 2,* Jerusalem, 1985.

Burial Society Glass, p. 96

I. Shachar, "Feast and Rejoice in Brotherly Love: Burial Society Glasses and Jugs from Bohemia and Moravia," *The Israel Museum News, no. 9,* Jerusalem, 1972.

Breastpieces, p. 98

J. Jouin, "Les Themes Decoratis Des Broderies Marocaines. Leur Caractere et Leurs Origines," *Hesperis 19,* Paris, 1936.

A. Muller-Lancet, *La Vie Juive au Maroc: Arts & Traditions,* Jerusalem, 1986.

A. Ben-Ami, "Decorated Shrouds from Tetouan, Morocco," *The Israel Museum Journal,* VIII, Jerusalem, 1989.

Woven Wool Carpet, p. 100

O. Schwartz, "Jewish Weaving in Kurdistan," *Journal of Jewish Art, Vols. 3 & 4,* Chicago, Illinois, 1977.

Circumcision Set, p. 102

C. Benjamin, *The Stieglitz Collection: Masterpieces of Jewish Art,* nos. 204–5, The Israel Museum, Jerusalem, 1987.

A. Parik, "From Middle Ages to Modern Times," in *Where Cultures Meet: The Story of the Jews of Czechoslovakia,* Natalie Berger, ed., Tel Aviv, 1990.

The Wedding, p. 104

Bilder aus dem Altjüdischen Familienleben nach originalgemälden von Moritz Oppenheim, mit einführung und erlauterrungen von Leopold Stein. Frankfurt am Main, H. Keller, 1882 (2nd ed. 1886). Reprinted in English: *Pictures of Traditional Jewish Family Life,* New York, 1976.

Moritz Oppenheim: The First Jewish Painter, Jerusalem, Israel Museum, 1983, cat. no. 238.

E. Cohen, "Moritz Oppenheim: The First Jewish Painter," *The Israel Museum News, no. 14,* 1978.

J. Gutman, "Wedding Customs and Ceremonies in Art," in *Beauty in Holiness,* New York, 1970.

Illustration for "Boat Ticket," p. 106

R. Apter-Gabriel, ed., *Tradition and Revolution: The Jewish Renaissance in Russian Avant-Garde Art, 1912–1928,* The Israel Museum, Jerusalem, 1987.

M. Perry-Lehmann, ed., *On Paper, In Paper, With Paper,* p. 186, The Israel Museum, Jerusalem, 1990.

Interior of a Synagogue in Safed, p. 108

M. Weyl, "Chagall's *Interior of a Synagogue in Safed,*" *The Israel Museum Journal, Vol. X,* pp. 23–30, Jerusalem, 1992.

The Sacrifice of Isaac, p. 110

A. Barzel, ed., *Menashe Kadishman: Sacrifice of Isaac, Sculpture and Painting,* Tel Aviv, 1985.

Still Life with Jewish Objects, p. 112

A. Kampf, "Jewish Experience in the Art of the Twentieth Century" (exhibition catalog), Jewish Museum, New York, 1975.

R. Apter-Gabriel, ed., *Tradition and Revolution, The Jewish Renaissance in Russian Avant-Garde Art, 1912–1928,* The Israel Museum, Jerusalem, 1987.

INDEX

Page numbers in *italics* denote illustrations.

Afghanistan, Torah decorations from, 13, 46, *47*

Algranati, David, 88, *89*

Amulet necklace, 90, *91*

Amuletic paper-cut (Algranati), 88, *89*

Ancient art
coin of Judah, 20, *21*
gold-glass base, 16, 24, *25*
ivory pomegranate, 18, *19*
mosaic pavement, 26, *27*
multiple-nozzle lamp, 28, *29*
oil lamp with menorah, 16, 30, *31*
sarcophagus from a Nazarite family tomb, 22, *22–23*

Arnstein, Seckel, and Sons, 76

Ashkenazi Jews, 10, 50, 58, 64, 82

Austria, *Five Scrolls* in micrography (Herlingen) from, 13, 68, *69*

Austro-Hungary, spice boxes from, *75*

Baruch ben Isaac, 94

Base, gold-glass, 16, 24, *25*

Bembo, Bonifacio, 62

Berman, Menahem, 14

Beth Shean mosaic, 26, *27*

Bezalel Museum, 9

Bezalel National Museum, 9, 10, *11*

Bezalel School of Arts and Crafts, 9

Birds' Head Haggadah, 10, 14, 16, 58, *59*

"Boat Ticket," illustration for (Lissitzky), 106, *107*

Boaz column, Temple in Jerusalem, 18, 20

Bohemia, art from
burial society glass, 96, *97*
circumcision set, 102, *103*

Breastpieces, 98, *99*

Bridal casket, 12, 94, *95*

Burial society glass, 96, *97*

Candlesticks, Sabbath (Segal), 14, 72, *73*

Carmi, Solomon ben Joseph, 60

Carpet, woven wool, 100, *101*

Ceiling, Horb Synagogue (Sussmann), 10, 13, 34, *35*

Central Europe, spice box from, *75*

Ceremonial art, 10, 16
Esther scroll, 80, *81*

hanging Sabbath lamps, 70, *71*
Hanukkah lamp, 78, *79*
ivory pomegranate, 18, *19*
lusterware Passover plate, 82, *83*
multiple-nozzle lamp, 28, *29*
Sabbath candlesticks (Segal), 14, 72, *73*
spice boxes, 13, 74, *75*
sukkah, 76, *77*
Torah decorations, *see* Torah decorations

Chagall, Marc, 9, 14, 108, *109*

Circumcision set, 102, *103*

Coin of Judah, 20, *21*

Corcos, Hezekiah Manoah, 44

Corcos, Isaac, 44

Corcos, Samuel, 44

Deller, Abraham, 76

de Pinto, Rachel, 92

Dov, Avraham, 64

Drentwett, Johann Christoph, 13, 50, *51*

Eastern Europe, prayer book of the Rabbi of Ruzhin from, 64, *65*

Ehrenburg, Ilya, 106

Elkone of Naumberg, 13, 40

Embroidery, 13
breastpieces, 98, *99*
Torah ark curtains, 13, 40, *41*
Torah mantles, 13, 42, *43*
Torah wrapper, 44, *44–45*

Ephraim of Regensburg, 58

Esther scroll, 80, *81*

Fall of Goliath, The (Shah), 86, *87*

Feuchtwanger, Heinrich, 9, 76

Feuchtwanger Collection, 9, 10

Finials, Torah, 38, *39*, 42, *43*, 46, *47*, 52, *53*, 56, *57*

Five Scrolls in micrography (Herlingen), 13, 68, *69*

Floral motifs, 20, *21*, 22, *22–23*, 42, *43*

Friedman, Israel, 64

Friedman Family, 64

Gans, Kopel, 13, 40

Germany, art from
 Birds' Head Haggadah, 10, 14, 16, 58, *59*
 Esther scroll, 80, *81*
 Hanukkah lamp, 78, *79*
 Horb Synagogue ceiling (Sussmann), 10, 34, *35*
 illustration for "Boat Ticket" (Lissitzky), 106, *107*
 mizrach, 84, *85*
 spice boxes, *75*
 sukkah, 76, *77*
 Torah ornaments, 13, 50, *51*, 52, *53*
 The Wedding (Oppenheim), 104, *105*
Gold-glass base, 16, 24, *25*
Grace after Meals (Nathan of Mezeritz), 13, 66, *67*
Gumbel, David, 14

Ha-Ari Sephardi Synagogue, 108, *109*
Ha-Levi, Moshe Hanoch, 56
Hanging Sabbath lamps, 70, *71*
Hanukkah lamp, 78, *79*
Herlingen, Aaron Wolf, 13, 68, *69*
Holland, marriage contract (Shalom Italia) from, 12, 92, *93*
Horb Synagogue ceiling (Sussmann), 10, 13, 34, *35*

Iconography, 14, 16
Ikat technique, 46
Illuminated manuscripts
 Birds' Head Haggadah, 10, 14, 16, 58, *59*
 Five Scrolls in micrography (Herlingen), 13, 68, *69*
 Grace after Meals (Nathan of Mezeritz), 13, 66, *67*
 prayer book of the Rabbi of Ruzhin, 64, *65*
 Rothschild Miscellany, 12, 16, 62, *63*
 Sassoon Spanish Haggadah, 10, 60, *61*
Illustration for "Boat Ticket" (Lissitzky), 106, *107*
"In Memory of the Destruction of the Temple" (Segal), 14
Interior of a synagogue in Safed (Chagall), 9, 108, *109*
Israel, art from
 The Fall of Goliath (Shah), 86, *87*
 Interior of a synagogue in Safed (Chagall), 108, *109*
 Sabbath candlesticks (Segal), 14, 72, *73*
 The Sacrifice of Isaac (Kadishman), 110, *111*
Israel Museum, The
 artists, 12–14
 history of collections, 9–10
 Julia and Leo Forchheimer Department
 of Jewish Ethnography, 10
 Max Mazin Wing for Jewish ceremonial art, *15*
 scope of collections, 10, 12
 Skirball Department of Judaica, 10
Isserles, Moses, 36
Italy, art from
 bridal casket, 12, 94, *95*
 Rothschild Miscellany, 12, 16, 62, *63*
 spice box, *75*
 Torah ornaments, 42, *43*
 Vittorio Veneto Synagogue, 12, 32, *33*
Ivory pomegranate, 18, *19*

Jachin column, Temple in Jerusalem, 18, 20

Jerusalem, art from
 coin of Judah, 20, *21*
 Ivory pomegranate, 18, *19*
 sarcophagus from a Nazarite family tomb, 22, *22–23*
Jewish art style, 14, 16
Jewish Cultural Reconstruction, 10
Jewish home and Jewish life
 amulet necklace, 90, *91*
 amuletic paper-cut (Algranati), 88, *89*
 breastpieces, 98, *99*
 bridal casket, 12, 94, *95*
 burial society glass, 96, *97*
 circumcision set, 102, *103*
 Fall of Goliath, The (Shah), 86, *87*
 marriage contract (Shalom Italia), 12, 92, *93*
 mizrach, 84, *85*
 woven wool carpet, 100, *101*

Kadishman, Menashe, 110, *111*
Kaub, Rechle, 40
Kerchiefs, 46, *47*
Keysar, Hayim Ben Shalom, 38
Kurdistan, woven wool carpet from, 100, *101*

Lamps, *see* Oil lamps
Lily motif, 20, *21*, 22, *22–23*
Lissitzky, El, 14, 106, *107*
Luria, Isaac Ben Solomon, 108
Lusterware Passover plate, 82, *83*

Mahzor (High Holiday and festival prayer book), 58, 76
Manuscript illumination, *see* Illuminated manuscripts
Marriage contract (Shalom Italia), 12, 92, *93*
Memorbuch (memory book), 40
Menahem, 58
Menorah motif, 16
Meshed Jews, 46
Mizrach, 84, *85*
Modena, Leone, 42
Modern art
 illustration for "Boat Ticket" (Lissitzky), 106, *107*
 Interior of a synagogue in Safed (Chagall), 9, 108, *109*
 The Sacrifice of Isaac (Kadishman), 110, *111*
 Still Life with Jewish Objects (Ryback), 9, 112, *113*
 The Wedding (Oppenheim), 104, *105*
Moldovan Family collection, 40
Moravia, *Grace after Meals* (Nathan of Mezeritz) from, 13, 66, *67*
Morocco, art from
 breastpieces, 98, *99*
 living room, *12*
Mosaic pavement, 26, *27*
Multiple-nozzle lamp, 28, *29*

Narkiss, Mordechai, 9, 94
Nathan of Mezeritz, 13, 66, *67*
Nazarites, 22
Necklace, amulet, 90, *91*

Obol, 20, *21*
Ofir, Arieh, 14
Oil lamps
 Hanukkah, 78, *79*
 with menorah, 16, 30, *31*
 multiple-nozzle, 28, *29*
 Sabbath, hanging, 70, *71*
Oppenheim, Moritz, 14, 104, *105*
Oriental Jews, 12

Pappenheim, Bertha, 52, *53*
Passover plate, lusterware, 82, *83*
Pereira, Isaac, 92
"Pictures of Traditional Jewish Family Life" (Oppenheim),
 14, 104
Plastrons, 98, *99*
Pointers, 42, *43*, 52, *53*
Poland, art from
 spice boxes, *75*
 Torah ark doors, 13, 16, 36, *37*
Pomegranate, ivory, 18, *19*
Pomegranate motif, 18, *19, 42*
Posen, Brendina, 52
Posen, Jacob, 13, 52, *53*
Posen, Lazarus Eliezer, 52
Posen Family, 52
Prayer book of the Rabbi of Ruzhin, 64, *65*
Prayer stand, 54, *55*
Predis, Cristoforo de, 62

Rema Synagogue, 36
Rome, art from
 gold-glass base, 16, 24, *25*
 Torah wrapper, 44, *45*
Rothschild Miscellany, 12, 16, 62, *63*
Round cloth, 13, 46, *47*
Ryback, Issachar, 9, 112, *113*

Sabbath candlesticks (Segal), 14, 72, *73*
Sabbath lamps, hanging, 70, *71*
Sacrifice of Isaac, The (Kadishman), 110, *111*
Sarcophagus from a Nazarite family tomb, 22, *22–23*
Sassoon, David Solomon, 60
Sassoon Spanish Haggadah, 10, 60, *61*
Schatz, Boris, 9
Schwartz, Yehosef, 76
Sefer Haminhagim (Book of Customs), 64
Sefer ha-Teruma (Baruch ben Isaac), 94
Segal, Zelig, 14, 72, *73*
Sephardi Jews, 10, 82, 92
Shah, Moses, 86, *87*
Shalom Italia, 12, 92, *93*
Shor, Amit, 14
Six Stories with Easy Endings (Ehrenburg), 106
Spain, art from
 lusterware Passover plate, 82, *83*
 Sassoon Spanish Haggadah, 10, 60, *61*
Spice boxes, 13, 74, *75*

Steiglitz, Abraham, 9
Steiglitz, Joseph, 9–10
Steiglitz Collection, 9–10
Stein, Leopold, 104
Still Life with Jewish Objects (Ryback), 9, 112, *113*
Sukkah, 76, *77*
Sukkot festival, 112, *113*
Sussmann, Eliezer, 10, 13, 34, *35*
Synagogue decorations
 Horb Synagogue ceiling (Sussmann), 10, 13, 34, *35*
 Interior of a synagogue in Safed (Chagall), 9, 108, *109*
 mosaic pavement, 26, *27*
 Vittorio Veneto Synagogue, 12, 32, *33*
Synagogue prayer stand, 12

Temple in Jerusalem, 18, 20, 26
Ticho, Abraham, 9
Ticho, Anna, 9
Torah decorations
 ark, 34
 ark curtains, 13, 40, *41*
 ark doors, 13, 16, 36, *37*
 binder, 42
 cases, 12, 46, *47*
 crowns, 42, *43*, 56, *57*
 finials, 38, *39, 42, 43*, 46, *47*, 52, *53*, 56, *57*
 hallmarks, 52, *53*
 kerchiefs, 46, *47*
 mantles, 13, 42, *43*
 ornaments (Posen), 13
 pointers, 42, *43*, 52, *53*
 prayer stand, 54, *55*
 round cloth, 13, 46, *47*
 shields, 13, 42, *43*, 48, *49, 50, 51*, 52, *53*
 wrapper, 44, *44–45*
Tovar, Yeshuron, 94
Turkey, art from
 amuletic paper-cut (Algranati), 88, *89*
 Torah shields, 48, *49*
Tyrnau, Isaac, 64

Vittorio Veneto Synagogue, 12, 32, *33*

Weaving, 13
Wedding, The (Oppenheim), 104, *105*
Weiss, Johann Conrad, 13
Wool carpet, woven, 100, *101*

Yemen, art from
 amulet necklace, 90, *91*
 prayer stand, 54, *55*
 Torah crown with finials, 54, *55*
 Torah finials, 38, *39*
YHD inscription, 20